Spoonful of Grey

Spoonful of Grey

Diana Romany

MapinLit
AN IMPRINT OF
MAPIN PUBLISHING

First published in India in 2005 by
MapinLit
An Imprint of
Mapin Publishing
Ahmedabad 380013 India
Tel: 91-79-2755 1833 / 2755 1793
Fax: 91-79-2755 0955
email: mapin@icenet.net
www.mapinpub.com

Text © Diana Romany
Jacket image: Chittrovanu Mazumdar
Courtesy: OSIAN's Connoisseurs of
Art Archive
Author Photograph by Ashok Jani

ISBN: 81-88204-43-9

For sale in the Indian Subcontinent only

Design by Janki Sutaria
Mapin Design Studio
Printed in India

Note to the reader:

My use of both British and
American spelling does not
reflect upon my editor or
publisher. It is merely the effect
of a collision between colonial
precedent and Microsoft Word.
The names, characters,
businesses, organizations,
places, events, incidents;
coincidental resemblance to
actual persons, living or dead,
events, and locales in this work
of fiction could not escape the
repercussions.

To my mother and father.
For caring and not caring,
in all the right places at all the right times.
Most of all, for being
the embodiments of imperfection and letting me be.

Blue Monday Morning

I wake up
open my eyes,
take my book and pen,
go outside Blue Monday Morning to write.

A poet usually looks at the sky.
Writes about birds, clouds, sun, moon
and their Family Tree.

But on a Blue Monday Morning
a poet can only write
stupid poems
like Blue Monday Morning.

- Sayuj 'Smokin' Jose

I

II

III

coda

I

chance-encounter routine

~

Make love to me, Sara says. It might not feel the same again, I tell her. We pretend she's a rich man's wife and arrange to meet at Orange. As if by pure chance. We pretend I'm somebody's dollface. I'm always somebody's baby.

She looks around over the rim of black coffee. We pretend we're taking chances. The blue smoke from the incense is the same color as the blue smoke of my Londons. She doesn't smoke. But she likes the nicotinelaced taste of my mouth when she puts her tongue in. Bombay is the most beautiful place in the world. I don't have to see the world to know that I'm not wrong. I can't bring myself to call it Mumbai. It's Mumbai only if I'm writing letters. I never write letters. I ate a big pack of chips on my way here. Saif Ali Khan stared from the pack. He looked very young and colorful. I wonder if he's like that really. It was almost empty. The train, I mean. Sara came by car. She calls it her Chevy. We're pretending she's a rich man's wife. I don't know how long it will last.

I love my cigarettes and a pocketful of gold more than I love her. I'm feeling guilty about not feeling guilty. Sara is beautiful. I don't think I care. I love places more than I love people. They're infinitely more interesting. Sara bores me. Two women walk into the café.

Accompanied by two men, of course. Everybody turns to stare at them. I love my cigarettes. Can't stand black coffee. It makes me think of my schoolteacher, Miss Janet. Miss Janet was thin and parched with big round eyes made bigger with spectacles, and scarlet fleshy lips. She was like a bird in a cage. I like tea. It's like drinking skin. They're dressed like harem women. That's why everybody's staring. That's the good thing about Bombay. Two harem women walk into a café but after that nobody cares. One in green and the other in yellow. They've even got veils and shiny sequins and smoky eyes. Just like in *I Dream of Jeannie*. The men with them are unremarkable but look very proud and pleased with themselves. After all, how many people can walk into Orange with harem women. Not many they're sure, I'm sure. Sara looked at them for a second. She's trying to look unaffected and not surprised. She's trying to see if I eye them. That's why Sara bores me. She's like everybody else.

The sun is setting. I love the color of dying sunlight. It comes in through the window and lights up my body. I feel like a stained glass window. Can almost hear churchbells. Like Larkin's glass of water. Sara looks at my eyes. Everybody does. Sunlight always makes that happen. Sparkling light brown and the whites are like communion wafer. Corpus Christi. I know I can make anybody fall in love with me. Sara doesn't know this. I watch her through blue cigarette smoke and listen to the traffic outside. I'm going out tonight with Rohan to Avalon. I'm wondering what to wear. I'll have a long bath after I go home and I'll smell of Chanel in the night. Rohan will rub his cheek against my neck and get an instant erection. I like him only when he's making love to me or dancing with me so people can watch. That's all we ever do. He's asked me to always be his baby. His bluejeaned baby. Wants to wake up with me, he says. Avalon is an amazing place to watch people. Dark and sordid, and people with just enough money trying to look like they're rolling in it. I'm going to slip away.

I love the chairs here. Dark wood. Ebony, I think. I could be wrong, though. Ebony's too expensive. Teak maybe. The new places have orange interiors. It makes people hungry, they say. Gives me a

headache. I think I was born old. Sara picks at her food. Her beauty comes from skipping and massages. She glances occasionally at the harem women when she thinks I'm not looking. I'm good at that. People always think I'm stoned. Makes me feel like I'm in Spy vs Spy. We walk out. Sara holds my hand in hers. I wonder where the driver has parked the car she came in. Her Chevy. I know he's been waiting all this time. I feel like a driver sometimes. Not even exclusive. I wish I could at least feel like a chauffeur.

There are stalls selling semi-precious stones right outside. I pick up something that looks like a crystal ball, I think it's marble. Sara pulls me along impatiently. Sometimes she hates herself I think. I may be right. She buys me a scarf that looks like glittering snakeskin. I knot it around my neck and somersault for her. Some assault. She claps her hands wildly and laughs out loud. I feel sorry for her. These are the days of her life. I watch her jewelled fingers come together and fall back and come together again. I must get home soon. I want to look stunning tonight and it takes time. She disappears into another shop. I wait outside and talk to the shoemaker. He's been here forever. The place is surrounded by the faint smell of leather or cowhide or whatever it is. He asks me if I want my shoes polished. I pay him for three tolas and take the ball of hash wrapped in foil. The week's supply. I tell him, No thanks, I'm wearing sandals. He pretends to look really sorry. I think I love my dope dealer more than I love Sara. I've left Orange so far behind it feels like another lifetime. I look down at my toes. The nails are painted blue. I like my body. Everybody does.

Sara comes out with something in a brown paper-bag. I realize suddenly that I've never seen her without a handbag. She's got them in all the colors of vibgyor. She gives me the paper-bag. I open it and find an indigo-colored box that's wood on the bottom and silver filigree on top. I lift the silver lid and find a pair of small silver hoop earrings. Very gypsy. I remember telling her in the afternoon that I hate gold and love silver because it reminds me of Judas Iscariot. She had laughed and rubbed the back of my neck. The earrings are pretty. I'll give them to Rohan. Sara has never noticed that my ears aren't

pierced. I thank her and kiss her cheek in gratitude. The box is perfect. I can keep weed in it. She opens her handbag and brings out a cellphone. It's got a red flip-open lid with a square of Swarovski crystals embedded on it. I wouldn't have known if she hadn't told me. Swarovski. Doesn't mean anything to me. Somebody's waiting for the bus. He's behind me, and the Walkman's too loud. It's a Sony. I think he's listening to Shaggy. Poor devil. Lived. Sara tells her driver to come and pick her up. She's rude.

She hails me a taxi. It's a black and yellow Ambassador. Premier Padmini, maybe. I couldn't care less. I want to take her home, I tell her. She looks at me with a sad face. I want to laugh out loud. She pays for my ride home. I tell her I love her again. She touches my cheek with two ringed fingers. One has a ruby on it and the other a sapphire. Nice colors. Fire and ice. I don't wait to watch her leave and get in. I feel like I'm having an out-of-body experience. I see myself get into the taxi and take my Discman out. It's a Sony. I see Sara standing dressed like someone in a soap opera and waving goodbye. Al Di Meola. Race With Devil on Spanish Highway in my ears. I want to run. It's like a bad dream. My legs don't move but I'm trying so hard.

The Ambassador (Premier Padmini, maybe) is a very comfortable car. I can watch the city pass by from the window. It's a class above what I could see from the train window. I smoke another cigarette with my head back on the seat. It's getting dark now. When I came out of the café I could see simultaneously in the sky a faint moon and the setting sun. Life must be gorgeous on Jupiter. I think I'll wear my raspberry print top. It'll show my collarbones. Mascara and a little lipstick. Faded Levis. That should do it. Rohan is like a dog. Never looks at what I'm wearing. Always stuck on smell. The seats feel weird. Some kind of furry stuff. Perhaps it's faux yeti-hide.

It's beautiful when I can sit back and keep moving under the nightlights brightlights. It's like watching Bombay bellydance.

bass player

A girl and a woman passed by Joseph as he walked into The Orange Café. The girl had a smoking mouth and a face nobody could forget. He went to his usual table by the jukebox and looked around at the Mario creations on the wall. This Mario guy had to be Goan. Joseph wasn't thinking too well through the drunken curtain clouding his brain. He wondered if he smelled regal and if there had been, somewhere in history, men named Mr. Jack Daniels or Mr. Johnny Walker. Also, he wasn't too sure if it was spelt Johnny or Johnnie on the bottles. The only reason he liked the place was because the furniture was all wood. Wood and metal could look good together only on a guitar. It wasn't a combination made for chairs. The chairs here felt solid and real. He gripped the sides of the table with his hands and stared straight ahead, seeing nothing. His head was reeling. He had no idea where his girl was. His girl. Not anymore by the looks of it. For the hundredth time since she had left he brought out the Polaroid from his wallet and sat looking at it. The waiter came and his thoughts had to be postponed. He ordered samosas and tea and threatened the waiter with death if it was bad. The waiter looked distractedly at the people in the far-left corner like he was hoping they would leave soon.

Joseph looked at the snapshot in his hand. It didn't show her face. She had given it to him before she left the last time. It showed her sitting

on an almost rotting tree trunk. Neck down. Dark blue jeans and striped shirt. The only skin she showed was a naked arm stretched out. She held out a green stone on her palm. It looked like it would fall any moment now. It looked like the only reason it didn't fall was because the camera stopped it. There was something erotic about the picture. He thought of her standing naked in the doorway, framed in light. Something made him catch his reflection on the glass top of the table. Even in the imitation of life his eyes looked bloodshot and red as if they'd been bleeding instead of crying. Cry, baby, cry, put your finger in your eye. For one horrible moment his mind remained blank when he tried to think of her. He felt like he'd been turned to roadkill. Then it came back and he could see the line of her jaw. Her ears and the way she could move her ears and make him laugh.

There was a menu sandwiched between the glass top and the table. He read it with incredulity.
Orange Juice—Shining skin
Grape Juice—Iron coated heart
Watermelon Juice—Internal clearence
Mango Juice—Lovly complexion
Mosambi Juice—Cool off soul
Litchi Juice—Nice night
Pineapple Juice—Sharp memory
Chocolate Milkshake—Healthy smile
+ All items availiable according to season

Milkshake didn't fit in there at all. The waiter came and went. Joseph sipped at his tea and wished he were somewhere on a ship while gulls circled overhead. The samosas smelt like home and his stomach felt like someone had cleaned it out with Drainex. He was scared he would throw up if he ate. Somewhere, a cellphone was ringing loud as a klaxon. The tea lined his insides. He put his hand out for the food and stopped midway when his eyes fell on the ketchup. It was too red to be true. Like the ink in gel pens. He thought he felt a rat scurrying over his foot and jerked back against the wall. The old lady at the table facing his stared at him. He looked under the table and found nothing,

like he knew he would. He ignored the woman with hair like Phil Donahue and picked up a samosa off the plate. He closed his eyes and hurriedly bit into it. The taste of spice and potato spread in his mouth and he gulped it down with tea. He ate it all and called out to the waiter for more of everything.

Joseph put the snapshot back into his wallet and wondered idly about the guy who had clicked that picture of her. He didn't know why he was so sure it was a guy. One of her ex-boyfriends, most probably. Couldn't be otherwise. He tried to think of the man's face and got angrier at each feature that came clear. Somebody tall with hair like in the Head & Shoulders ads who fucked like a maniac. Maybe he had bitten her neck or licked her cunt or fingered every square inch of her body just like Joseph had done every night since he had met her. Joseph glared at the waiter when he came back with the second order. He hurried away. Joseph wished he had his guitar. She had told him that in the days of old guitar strings were made of sheep intestines. It was a revolting thought. Making the insides of some dead animal sing.

It was dark when he came out. He felt his stomach sag with the weight of the food inside it. He mistook another car for his and set the alarm off trying to open it. He moved away hurriedly to his own car and let himself in behind the wheel. Joseph saw a fat man in a safari suit run towards the shrieking Lancer and switch off the alarm, checking it for signs of a break-in. He turned the key in the ignition and got stuck in the traffic almost as soon as he got the car out of the parking.

At the traffic light a young boy with his ribs showing tapped on the window. Joseph saw the dark outline of a Hanuman mask and wondered bizzarely if the Hanuman Boy could fly. The boy had one of those things Bhim carried over his shoulder in the old Mahabharat serials. A cardboard gada, if that's what it was called. All he wanted to do was get home to his guitar. Fuck the girl. He didn't need her. He still had his guitar. Just like Jimi, he thought. Just like Jimi. Pity this one didn't have a sister. Joseph smiled to himself.

The lights turned green. He shut off the air-conditioning and let the windows down. He felt the wind in his hair and did 90 on the flyover. Life is beautiful, he thought and smiled again.

He didn't mind doing covers. He could do it for the rest of his life, in fact. It made him feel like a thief but being original was too much of a strain. He called up Sarkar on his cell and told him he was free to play on the Colosseum night. Sarkar sounded relieved and told him money wasn't an issue. He would pay anything Joseph asked for. Joseph cut the call and eased back on the seat. The citylights whizzed by. He felt like a stone splash into his stomach and ignored the pain. He wondered what sheep felt like on a guitar and figured they never lived to see it. He wondered if thieves go to heaven and figured they did; if it was all done by the book with a crucifixion at the end. With Christ by your side nothing could go wrong.

encomium

~

She's a witch of trouble in electric blue.
In her own mad mind she's in love with you,
With you.
Now what you gonna do?

Cream, *Strange Brew*

Rhett stood near the rusting red BUS-STOP sign. He didn't notice that his Walkman was playing with the mode switched on to radio so he wasn't really listening to anything he wanted to. He was transfixed by the traffic that flowed by steadily in front of him and vaguely registered the signboard across the street that said Kashmir State Arts and Handicrafts Emporium. A brilliantly embroidered peacock-blue shawl hung on display. If his eyes weren't deceiving him, there were also elephants carved in wood on one of the shelves. He was pretty sure there were no elephants in Kashmir. He wondered how they'd ended up there. In his head he rewound and played over and over all the parts he remembered from last night.

~

It had started with him going to Piku and Pommie's house to pick up his K&D CDs. His car got a flat on the way and he didn't have a spare. He had had to spend an hour being driven around in a rickshaw before he found a garage that was open on Ganesh Chaturthi. If it hadn't been for that he would have never seen the angel open the door for him. Or so he felt. She wore dangerously low faded blues and a shirt the color of ash. It was buttoned up to somewhere right between her breasts. He saw a curve of mocha flesh and the laced edge of a bra when she moved aside to let him in.

Piku and Pommie jamming with Meyrick. Manali fragrance in the air. He joined them on the floor and took the guitar from Meyrick to play a quick riff. She wasn't anywhere to be seen. He played around with the water circles the beer bottles had left on the floor.
'Who opened the door?' he asked Piku.
'Meyrick's sister.'
He turned to Meyrick. 'Never knew you had a sister.'
'I keep forgetting.'
Piku and Pommie laughed hysterically. Rhett ignored them.
'What's her name?' he asked Meyrick, aware that he was acting like an idiot. He should have shut up.

'Chameli. What's yours?' The voice came from behind him.
He turned and saw her sitting on the floor with her knees pulled up and her back against the door. She looked at him from between her knees. He noticed the deep neckline and the silver chain around her throat. The pendant looked like a coin. He heard laughter again. Meyrick's voice joined the rest.
'Rhett,' he said and didn't turn away.
'Like Butler?'
'Like Butler.'
She stood up and walked over to sit beside him. Like a guitar sweep in motion.
'Where's my bag, Meyrick?' she asked her brother.
Meyrick put his hand behind him and groped around on the floor. He pulled a red bag with a pattern woven on it in black and passed it to her.

Rhett had never seen fabric like what it was made of. She took out a spectacle case from her bag and opened it with a loud click. She brought out a chillum. The bag lay on the floor in front of her. It was made of cloth, with a broad shoulder strap but he couldn't see any seams on it. A flap of cloth fell over the mouth of the bag. Rhett touched the stuff. It looked fine to the eye but was coarse to the touch. She pushed the bag towards him.

'You can see it if you want to.'

'Thanks.'

Rhett touched the cloth and outlined the pattern on it with his forefinger. It was like a sharp hourglass. Like two triangles with the tip of one balancing on the other. When he lifted the flap there was another pattern that looked strangely similar to the one on the flap. It looked like a sharp B. The way it would look if it were written in Roman or Greek. One of those languages anyway. Or was it Latin? Pommie had put on something and Led Zeppelin rang out, sounding eerie.

She tapped the mouth of the chillum on the floor and the gitti fell out. She picked it up and blew sharply on it.

'I'm taking it for granted that you stone,' she told him without looking at his face. He felt like he was dreaming with his eyes wide open. Like flying on mescalin.

'Your name's really Chameli?' he asked.

She looked straight at him. He saw for the first time the dark grey eyes that shone out of mocha skin. The colors mesmerized and repulsed at the same time. He looked at her fingers. They were slender and short. Her nails cut so deep he wondered if she bit them. But the edges weren't ragged. She didn't look like someone who bit her nails. There was a translucent pale-green band on her ring finger. She mixed the hash into tobacco in the palm of her hand. She looked down at her own fingers working on the stuff.

'What's wrong with Chameli?' she asked him.

'Don't take his case,' Meyrick told her.

They were back to jamming and Rhett wondered when the guitar had been taken from him. She grinned suddenly and tilted the edge of her

palm into the mouth of the chillum. She filled the mixed stuff in carefully and didn't let anything escape.

'One pauva charas and two bada Gold Flakes. Ever done that before?' she asked.

She didn't have an accent but it sounded weird, the way she said pauva and bada.

'Don't know. If I have I don't remember,' he said.

'Got to remember. Be aware of the rules so you can break them. The system, you know,' she said seriously.

She gathered up the last of the stuff pinched between her fingers and put it into the chillum like she was garnishing it. She held it upright in one hand and wiped the other on her jeans. She held the chillum out to him. She pulled her bag across towards herself and lifted its flap to bring out what looked like a CD holder. She unzipped it and he saw that it held a hand-mirror, a silver spoon, a pack of ganja, a red pack of big-size Rizla, small scissors and side strips cut out from cigarette packs ready to be made into roaches. He looked up at her face and thought he saw her dilated pupils expand and contract like a cat's.

'You married or engaged or something?' he asked.

'Sort of.'

He felt his stomach turn.

'To whom?'

'To myself. We is us.'

Meyrick laughed out with his sister and she grinned back at him.

'Stop taking his case,' he told her again, 'He's a nice boy. Really.' He turned to Rhett. 'She just likes taking case when she's stoned. Ignore her.'

She put her hand into her backpocket and brought out a matchbox. She struck a match and it flared in her hand. He held the chillum to his mouth and waited for her to light it. She put the match out with a flick of her wrist.

'You smoke it Taliban style. That sucks.' She got up on her knees and put her hands around his. They were cold. 'Don't hold it between the last two fingers.' She got him to hold the chillum between his middle

and index finger and brought his thumb to make a circle around it so he was supporting it with the base of his middle finger. She winked at him. 'Hold it like you love it.' She lit another match. 'Pull,' she said and kissed the flame to the mouth of the chillum.

He pulled and the smoke hit his lungs.
'Müari Agostina Rodriguez at your service. My brother calls me Ari. You can call me Al.'
She laughed out loud and sat back. It sounded like glass shattering.
He passed the chillum to her. She took it and easily deepdragged on it before passing it to Piku. She didn't exhale for a whole blue eon and when she did the smoke came out slow through her nostrils and then through her barely open mouth.
'Thought you were Meyrick's sister,' he said before he could stop himself and heard his voice float in from far away.

She turned the box of matches this way and that in her hand for a long time before answering.
'Two fathers. The same mother. We're the children of a Trinity.'
He looked at Meyrick who was busy smoking up. He looked back at her. 'Your dad's a firang?'
'Mexican. Half Huichol Indian. He's got no idea what the other half is.'
She put the matches back in her pocket and faced him. Silence like the pause between two songs.
'Is that Mexican stuff?' He pointed at the bag.
'Navajo.' She traced the pattern on the flap like he had done.
He felt like the lights were off and he was talking to a shamaness. Her voice came dancing through the air to his ears.
'This is a Born for Water symbol. It is how the Changing Woman's hair is tied during her Blessingway.' She lifted the flap and traced the sharp B.
He could hear guitar strings in the distance. Sounded like Cream.
'This one's a bow. Doesn't look like one but it is. Reminds me of a fiddle for some reason. It's called the Monster Slayer.... The Twins found smoke coming out of a hole in the ground and found the Spider Woman weaving.... I'm too stoned to talk. Leave me alone.' She stood

up and went to the window. She stood staring out of the window and didn't say anything till they left. He was stuck for the rest of the night. He kept thinking of how she could make a word sound so important that it already had capitals by the time it reached his ear. He could see the top of a notebook peeping out from her bag. It had Susan written in tiny letters and stuck over with sellotape right at the edge. He wished he could go through it and hurriedly rid the thought when he saw her looking at him. Almost like she could read his mind.

He waited, not wanting to leave before she did. After ages, Meyrick walked over to her. They stood near the window, talking in low voices. She stared straight at him over Meyrick's shoulder and pulled her eyes back to her brother who laughed and shook his head.

'Hey, Butlerface,' she called out to him, 'How do you travel?'

He stared at her stupidly before asking, 'What?'

'Travel. You know. Like get from one place to another. Car, bike, tuktuk or broomstick?'

'What's a tuktuk?'

'Tell him what's a tuktuk, Meyrick,' she told her brother.

'Rickshaw,' Meyrick said, sounding vague and lost.

'Car,' he told her.

'What car?'

'Gypsy.'

'Gypsy…nice, nice…I like. Hard-top or soft-top?'

She'd licked her lips and tried to look lecherous when she'd said I like. He thought it was cute.

'Soft-top.'

'You want to drive me home?'

'Yes,' he said and turned red when she laughed.

'Bye Meyrick. See you someday.' She kissed her brother on his cheek and walked away from the window. She came and knelt in front of him. For a moment he thought she was going to kiss him too but she picked up her bag and slung it over her shoulder. Her shirt lifted a little and he thought he saw the edge of a tattoo just above the waist of her pants. She caught him looking and pulled her shirt down.

'You coming or I go alone?' she asked looking at the door.

They went out far on the Expressway. The car smelled alien. She felt cold and took his sweatshirt when he offered it to her. He hoped the sweatshirt would smell like her later. He wondered if he was just stoned or if the whole world was really glittering. It was like having walked through a mirror. He saw her looking at him in the rearview mirror. She held his gaze for a second and then turned her head to look out of the window.

'That ring on your finger. I really want to know what it's made of.'

'Jade,' she answered without looking at him.

They stopped by the road because she said she wanted to stretch. She disappeared for a while and came back with the bag slung around her neck.

'Where did you go?'

'Good you didn't come looking for me. Would have embarrassed you.'

She looked up at the moon and he saw the silver chain on her neck. He raised his hand to touch it but she moved back sharply.

'Sorry,' he said.

She unclasped the chain and handed it to him. He held it out in front of the headlight. It was a one-cent coin. CANADA 1969 it said above a maple leaf on one side and the imprint of Queen Elizabeth's head on the other. There was a tiny hole drilled into the top and a thin silver wire passed through it to make a loop. The silver chain passed through the loop. He gave it back to her. She wore it around her neck again.

'You want to see the tattoo?' she asked with her face in the shadows.

'Yes.'

She moved over and stood in front of the headlight and lifted the corner of her shirt. She unzipped her pants to bring the waist down. He saw two triangles outlined with the bases facing and the tips pointing away. There was an intricately done circle around it.

'That's my name,' she said and tapped her finger on the outer edge of the circle on her skin. He kneeled down in front of her. It looked like geometrical creeper more than anything else.

'That's Shipibo art.' She still had her finger on the circle. She moved it in to the triangles. 'That's Navajo. Like on the bag.'These are the eyeholes of the initiation mask,' she said and pulled her shirt down. She zipped up and looked down at him. The coin was suspended at the base of her throat when she bent down. She had tasted like wilderness and hashish.

On the way back she didn't say anything.
'Do you like Led Zeppelin?'
'Maybe,' she said.
He had played it and she'd put D'yer Ma'ker on forever. When they reached Meyrick's apartment she simply opened the door of the car and let herself out. He saw her walk up the lighted stairway.

∼

Rhett realized that he was listening to the radio and switched the Walkman off in disgust. He made up his mind and crossed the traffic over to the handicrafts shop. He watched the salesgirl wrap up the box, which the shawl was in, with irritation. She didn't seem to care. He took the box away from her and walked out of the shop. He almost stumbled and fell over something on the pavement in his hurry. He bought wrapping paper on his way home. It was handmade black paper with silver stripes. He spent a long time getting it right and finally tied the satin ribbon carefully into a bow and kept the box on the table. He felt like making dinner.

He looked in the mirror and remembered that he'd forgotten to pick up his Discman from Piku and Pommie. He was stuck with the Walkman. He felt like he was soaked in scotch, standing in a maple leaf twister. He dialled Meyrick's number. The sweatshirt hadn't smelt of her.

pavement artist

~

She sat on the steps of the tailor-shop that had been closed down in 96 and turned the glass paperweight around in her hands. Inside the paperweight was a ballerina dancing, frozen in attitude. The ballerina wore a silly tutu that looked quite solid and real. She had never seen a ballerina in real life. This one was white all over, like the Pillsbury man, with features outlined in black and black-painted feet that didn't look like satin slippers at all. If she turned the paperweight upside down, snowflakes swirled down from the glass floor to the glass dome and fell on to the tiny dancer someone had a pushed a pause button on. She had been waiting since morning knowing that her music man would come. She saw him walking in and out of the café on unsteady feet and no time passed by. She knew she had been right. He never did anything out of the ordinary.

She wondered what she was thinking about and didn't want to get up in case her legs gave up on her. It wasn't a good idea to move too much after getting irrevocably nitroed into serenity. It was a perfectly lazy day—made for staring at Nina caught in the glass paperweight. Snowflakes in the glasshouse. It was becoming harder and harder to glow. Harder to feel sad without electricity. The music man had once played for her and it had sounded like petals fading. Like downstream water hitting pebbles. Now time had given up waiting for the perfect

moment and had moved on. Her wrist felt like it was throbbing. She tied her red bandana around it. The paperweight was so small and the dancer smaller still. How would she know Nina from the pretty ballerina? All she knew was that every picture told a story. The ones in nursery rhyme books, on billboards, on the covers of bestsellers. It was good to be on the other side of traffic. Over the hills and a long way off. Good to look through the periscope and not at the mirror. To see jellyfish and squid swim by and not wheels turning, always turning.

Like in the story of the little girls with not yet breasts but still women. They were mermaids doomed to walk on invisible knives and scream quietly with each step. They would walk or run or crawl up the sides of the mountain in spite of the pain. Anything to get up there. Once they were on top of the world the naked mangod would come and hold the chosen one high over his head. Many are called. The first rays of the huntress moon would fall across the altar and strike the never trespassed head of the Virgin chosen to give up blonde hair and untouched skin. It was all so holy. The mountainside would pulse and the angels sing with the sacrifice. The train would blow its whistle so loud that nothing except an avalanche was possible.

Like in the story of the blood red roses that bloomed out of the mouths of babes and put out tongues that twisted themselves around anything that tried to breathe the sweet, sweet smell away. Four roses. One each for all the corners of the room. It was magic, all right. To see the world through rose-tinted glasses and speak in tongues.

So many feet walked by in so many shoes and she saw colors and heard voices and felt nothing because everything came easy to her. Nina, pretty ballerina. It was such a stupid song.

Like in the story of the orange-faced girl who refused to take off her dark sunglasses even while she slept and anybody who looked into them could see Fame standing in front of a sea of faces with his body thrown back and fingers strangling the neck of his guitar. Fame was lit up by purple spotlights and covered by stage-smoke. She wasted

away, the orange-faced girl, because she opened her mouth for anybody who came by with a guitar. She sang songs worth nothing but sixpence and everybody cheated her out of royalty. Even the Queen.

Like in the story of the underwater baby who was born special because he could talk to dolphins. America came by and put him in a plastic bubble and invented a trademark for his body so they could have his intellectual property all to themselves and safeguard it. He woke up one night and found that nothing destroyed plastic. There wasn't even enough Time in the world to do it. He cried so hard that the bubble slowly became the sea. But America came by again and fished him out hook, line and sinker and don't forget the dollar for bait. Even before he was born the boy knew that if he saw a Franklin he must follow it. He didn't die but he drowned the whole unconscious world in water. Turned out that Mr. President had an informer with a Swiss bank account on Noah's ark. Everybody on the side of the White Whale was saved. The dogs learnt to howl the Star Spangled Banner and were given a special berth. The story of how civilization was saved. Nevermind.

Life turned around and bit her when she least expected it. The paperweight fell down from her hands but didn't break. Thoughtless feet came by and stumbled on it and forgot to curse. It rolled out onto the street where she couldn't save it. The ballerina continued to dance fixedly and in the snowflaked glass dome there flew tiny, crazy gulls. Three wheels went by before she saw it again. It lay on the road crushed under the weight of the world. Like a wedding cake used for a food fight. The ballerina never knew what hit her.

She walked back to nowhere with her head held high and shuffling humanity flowed by on both sides in all directions. A cameraman getting his shoes polished moved aside to let her pass. She turned back only once. Only because she could see herself all the time. She never needed a mirror.

Come, I'll show you my good time.

truth serum

~

His chin was cleft and he had dead, streaky blonde hair and icy, blue eyes stoned on flake. I don't know why I went with him. He made me feel like I had no regrets, I guess.

What did we do?

Soaked in a tub and came out smelling of bleach. He didn't have any eyebrows. Well, hardly any. And his body was hairless except for the golden powderpuff at his you-know-what. Like Dexter. I know. It sounds crazy.

What did he do?

He sang me to sleep and when I woke up he was in me and I turned pale. Like lilywhite, you know.

What did I do?

I don't know. Stared at this goldfish swimming around in this big glass bowl. It looked like it was dreaming. Like, you know, of something big. Like the sea or something. That's all I remember doing, anyway. If I did anything else, I've forgotten. It was therapeutic almost.

Distinguishing features?

Well, he smiled a lot. All the time. And it wasn't fake like on TV. Not like Oprah, or that big guy with big teeth—Tony Robbins, I think his name is. It was real. And it was scary because it was so real. All the time. Nothing's real all the time. Know what I mean?

Where did we go?

I'm sorry. I couldn't tell you anything about that even if I wanted to. I wasn't in the right frame of mind to notice. My mind walked out on me. Changed frames, so to say. It was in this place with clouds and I think there was a jetplane parked somewhere near so we could make a quick getaway if we had to. No trees. Just this big, tarred road. It could've been anywhere. Is there a big, tarred road next door? It could've been next door for all I know.

What did he tell me?

Lies. He told me a whole pack of lies. I don't want to repeat the things he said. Because then I'd be lying. You don't want me to lie, do you? You told me not to lie. But I'll lie if you want me to. Just don't hurt me, okay? I've been hurt enough as it is. Not that kind of hurt, you idiot. Haven't you seen *any* Oliver Stone movies?

What did he give me?

He said his name was Jack and gave me beans. Pretty hilarious, if you think about it. Lots of them in different colors. I almost buried them but then remembered that this was no fairytale. It would have been futile. I didn't do anything. You're not paid to think, you say? Good for you. You shouldn't, you know. If they don't pay you enough, ask for a raise. It's a free country.

Was I aware?

Of course not. You think I'm stupid or something? Why're you moving away? Scared, are you? Relax. I don't bite. I'm just being positive. Think positive. All your fears are baseless.

Why was I there?

I don't know. That's for some version of god to answer, isn't it? Fate, destiny—call it whatever you want to. And I wasn't really there, if you get my drift. It's this alternative reality thing. The way of Tao. Everything is possible and nothing at all. I *wasn't* there, if you ask me.

What time?

That I can tell you. I remember because I looked at my watch. It was tenten. Like in the Titan watch ads. That's Mozart they play, by the way. Symphony 25 in G minor. Tell me you never knew that. Figures. I'd sigh if I could, you know.

What day?

You're shitting me, aren't you? If I knew what day, why would I be sitting here having this titillating conversation with you?

Where did he come from?

From hell, he said when I asked him. He was a pretty funny guy, you know. Cute as a dog.

Was this the first time?

Hell, yes. I'm the space monkey, remember? They always test the product on animals first. I'm the first on everybody's list. Why're you asking me so many questions?

Do I remember anything else?

Yes. That eclipse…happened exactly when I saw him. Will that be all? I want to leave now. Let me go in peace to love and serve the Lord.

Sign where? Here?

There you go. You're almost as ugly as I am, you know. May the force be with you. Remember that with great power comes great responsibility. Damn Yankees. They're crazy. But I don't have to tell you that.

I may leave?

Of course I *may*, you dunderhead. Dunderhead. Now that's a funny word. Dunderhead. I would have left anyway. Stone walls do not a prison make. Ever heard of that one? I got a question for you since you asked me so many. You've seen Neil Armstrong? Yeah…his eyes gleam with recognition. All that giant step shit? All that moonwalking? You're not as dumb as you look. Who shot Armstrong? No, you asswipe. Not as in kill. Who was holding the camera when he got off his spaceship to do his stunts? Ever thought of that? Some people think it never happened. I don't have any opinions at all. But *you* should try figuring it out. Like I said, ask for a raise.

mystereons

~

Nobody listens to anything I say anymore. I told this marionette that I heard something crunch under the wheel of the car. 'This is Mumbai, Ammachi. If something comes under the wheel it gets crushed. You don't stop for it,' she says. I refuse to believe that there's anything of me in her though they say that this DNA thing carries a long way. They also say that you live for three hundred years if you take out all your reproductive organs. They tried it on worms apparently. Next they'll be telling me to scoop my brains out of my skull to live a carefree life. Cars these days are so roomy. This one's called a Scorpio. I've become like a dog. They take me out every evening for a walk and come back for me when I'm done. Meanwhile, I sit and look around. Should probably be put to sleep. Senile.

I was a woman wrapped up in satin and propped up on stage. They forgot to take me along when the play was over and the standing ovations emptied out of the hall. I stood and stared at the empty seats for so long that it's become the only memory I have. One of the only memories I have. Maybe they're right and the only decent thing to do would be to put me to sleep. I had a house all to myself. With French windows that looked out on to the sea and big white muslin curtains that billowed in and out with the breeze. I had an overstuffed armchair I could sink in. Stunning, they used to say. It was grotesque. To watch

my hair turn white and it happened so slowly it took a whole, unholy lifetime. One of my breasts fell out along the way. Got special blouses stitched for me after that. Blouses with one flat side and one side with enough space for the remaining breast to rest in. Breast to rest. Breast to rest.

The sunlight used to come in through the window those days. The armchair had a pattern of black roses on it. My shipbreaker died too soon. When an old ship came in to be turned to scrap I was always taken on a tour of the decks. To see if there was anything I wanted to take. I used to have entire ships to myself. I knew I wanted that armchair the moment I saw it. That was before Stella was born. A year after Priscilla was born and when I was carrying Adrian. When he was inside me, I used to spend all my time sleeping in that armchair. These days the sunlight stops at the door like a postman delivering bad news. Priscilla could never write 8 the right way. She still doesn't. She was always a muddled child. It was in the captain's cabin, that armchair. There was also a French dinner-set in pink crystal. But I left that alone. I just wanted the armchair. Black roses.

Sometimes he would bring home strange things. Small pills that melted and turned into all kinds of sponge animals if you put them in hot water. And once an iron bust from Africa of a goddess who swallowed coins if you put one in her hand and pulled a lever. He had taken it apart to see how it worked and could never put it all back together again. Adrian's daughter is ugly and dresses obscenely. Doesn't have a brain in her head. I like Stella's daughter. That Cheryl may be a small little thing but she's a sharp one. Always has her nose stuck in some book or the other. Looks nice too. Adrian drinks too much. He'll go the way his father went. She's always on the phone, this one. She hangs it around her neck and if she's not talking into it she's playing some mindless game or the other on it. A whole generation of infidels and popstars. I can still play almost the whole of the Fifth Symphony. Not one of my grandchildren has an ear for music. Except for that Cheryl. But she couldn't play the piano to save her life. She listens though. Small mercy. The three of them got together and

installed me in an apartment. It's got a lift that makes my stomach feel funny. When I lie in bed I feel like I'm sleeping on somebody's ceiling and looking up at somebody else's floor. It was a good marriage. I was left to myself most of the time in Goa. I miss the piano.

Cheryl was all excited one day and showed me some tapes. 'Ammachi, please listen to this. It's heavy stuff. I'll put it on low so we can listen to it together,' she said. Heavy stuff, my foot. I told her that I'd heard it all before in the days when her grandfather used to bring home records from the ships he took apart. I made her listen to Wagner. My Pappi was impressed enough to bring her boyfriend to my home after that. I should call her. He's a shaggy dog-like animal much like the ones Stella used to bring home in her days. Look who followed me home, Maman.

It's safer in an apartment. The security will always be around in case of trouble and you refuse to live with any of us. That's what they said. They put me into a box suspended in mid-air. They think electricity will last forever, all of them. I will leave this city. I may be an old woman but they can't stop me from living on the ground and dying with dignity. I'll go back to Calangute. Goa is filled with foreigners and pimps these days. Stella will know what to do. She'll understand that I've earned the right to breathe free. 'Ammachi, dad asked me to bring you home before I drop you off at Lokhandwala. Okay?'

The only time she has gotten off that phone so far. Why does Adrian want to see me? This girl has terrible taste in music and clothes and everything else. She's listening to something and all the songs sound the same. Doesn't sound like the man singing the songs has written the words. She's wearing pants that come down low. They show her divide. Her flesh falls out over the waistband of her pants. Adrian doesn't know where his children are going. His wife hates their neighbors because they have an E-class Mercedes Benz. Neither owns a house on solid ground. What's the use of keeping up with the Joneses if all you do is build castles in the air?

Even the lawns here look factory-made. There's a dog urinating on the ferns. This is where all the children come down to play for two hours each evening. Three on holidays. I want to see my Cheryl.

'Ammachi...Ammachi...we're here.'
Like I'm too stupid to notice. She gets out and slams the door shut. My bones ache. They have been fighting the earth for too long. I have to check the wheel to see if I was right.
'Not that way, Ammachi. Come this way.'
Like a dog. Roll over Rover. Let my Ammachi take over. I knew I was right. There's glass stuck in the grooves. I wonder what it was that the car ran over. Well, at least it wasn't over anyone's life. Small mercy.

the nun's tale

The bus rambled on and stopped at places she had never seen before. It was exactly as everybody had told her it would be. The city was loud and terrible but also serene somehow. She didn't even feel like a Carmelite Sister anymore. Sister Mary Teresa from the Kanjirapally Diocese was too far away from home. The city made her feel like a prostitute. She crossed herself but couldn't take her eyes off the scene at the window. It changed every second. She had been in buses in Kerala but that was nothing compared to this. This was like travelling through somebody's intestines. She felt like a heretic. It revolted her—this city. The buses in Kerala smelled like coconut oil and stale sweat. Here they smelled like rancid perfume. She couldn't decide which was worse.

There were too many theatres in the city. It was impossible to keep track of all the ones that passed by. And these strange women with their saris pulled between their legs and tucked into the small of the back. She tried to think of words to explain to herself how they wore the sari but couldn't. She held on to her purse and craned her neck to see if she could find Sister Alice. She couldn't. They hadn't been able to find seats together and Sister Alice had been kind enough to let her be seated first. Sister Alice had held on to the side of a seat and had stood around looking like a hawk. When she'd spied a woman getting

off, she'd swooped down and taken the seat. It hadn't seemed pious at all, the way she did it.

She saw shops that were impossibly huge. Of course, it wasn't as if she was a country bumpkin or something. They wouldn't send her to Italy to study further if she had been one. She'd seen the Alukkas showroom in Ernakulam, hadn't she? It was just that, well, Mumbai was just indecent. The bus made another stop and she saw Sister Alice rushing towards her through the hive of people and take her bag off the luggage rack overhead. Sister Alice clutched at her hand and pulled her up. Somebody took her seat immediately. They got off and Sister Mary Teresa almost fell off the bus in her hurry.

She stood and watched the bus move away to the left out of her sight. The scene was that of a thousand cars that went by never ceasing. She could hardly believe that there were so many people in the world. Of course, cars took up more space than people but that was no explanation.
'Let's go get something to eat. I'm so tired I might faint.'
Sister Mary Teresa looked at the woman who had been sent to pick her up at the station.
'Shouldn't we be getting back to the convent? It's almost dark.'
'Dark, shmark. Who cares? I'm hungry.'

They went to a place with impossible cartoons on the wall that looked like the ones on packets of Amul butter. Sister Alice pushed the menu at her. Was this kind of thing normal? Wasn't she scared that somebody from the convent might see? And where did she get the money to come to a place like this? She fervently hoped that Sister Alice didn't smoke cigarettes or something. That kind of secret she would certainly not be able to keep.
'Order a pastry,' Sister Alice told her.
'I'll just have coffee. Black,' she replied primly.
'Your wish,' Sister Alice said with a shrug.

When the food was brought to the table Sister Alice eyed hers with obvious relish before attacking it. It looked like cake covered with

whipped cream and chocolate with a cherry on the top. It looked impossibly fluffy and delicate. Sister Mary Teresa's mouth watered and she felt her knees go weak. She suddenly noticed that the place was filled with hundreds, no, thousands of delectable smells that came in from everywhere. She remembered watching a Mickey Mouse cartoon with her nephew once. It had shown an aroma in the shape of a smoky hand caress Mickey Mouse's face and lead him by the nose to a blueberry pie on Goofy's window-sill. She sipped at her coffee. It tasted bitter.

'Taste a spoon of this. Really. Your train was so late. You must be hungry.'

Sister Alice pushed a half-eaten pastry towards her. The cherry was still on top. Was she saving the best for last?

'Go on,' Sister Alice urged her.

One spoon couldn't do any harm, could it? Sister Alice held the spoon out towards her. The sun hit the handle and bounced off it. Sister Mary Teresa slowly put her cup down. It made a clink when the base hit the saucer.

She took the spoon Sister Alice held out like she would take an offering. She scooped a little off the half-eaten side. She gave Sister Alice's spoon back to her.

'If it doesn't seem too rude, may I order one for myself?' she heard her own voice asking Sister Alice.

'Of course. Go ahead.'

Sister Alice pushed the menu across the table for the second time. Even Christ had resisted thrice, a voice in her head spoke up. She told herself not to be silly. A pastry wasn't the earth and Sister Alice was hardly the devil. She thought of wolves in sheep's clothing and hesitated again. She pushed the thought firmly out of her head and looked at the menu under Pastries. Good Lord, she'd never known there were so many. It all sounded so exotic. Black Forest, Jamaican Pudding, Black Widow, Chocolate Éclair, Lady Jane, Strawberry Surprise, Voodoo Chile, Pineapple Dream...she ran her finger down the list and finally came to rest at one impossible name.

'Death by Chocolate,' she said out loud and looked up at Sister Alice.

Sister Alice was grinning broadly at her. She wondered what if it had been a test and she had somehow failed. But the look on Sister Alice's face confirmed that it was just joy. As if reading her mind, 'Excellent choice,' said Sister Alice.

Sister Mary Teresa sat back on the chair and smiled beatifically at Sister Alice. She was going to hell anyway, she told herself. Might as well go for a pastry as for a puff.
'Ethayalum Mariyamma neragathilota,' she muttered under her breath and was pleasantly surprised when Sister Alice threw back her head and shrieked out in laughter while beckoning to the waiter to come to the table. The people around smiled indulgently at the nuns as if patting them on their backs. Sister Alice kept shaking her head and wiping her tears off on the sleeves of her habit. When the pastry finally came, Sister Mary Teresa felt like she had been kept waiting ages for it.

It was almost black. The exact color of the backrest of the chairs. There was no cherry on top. It looked like the newly tarred roads she had sometimes seen shining in the sunlight just after the rain. She waited for a second, with the spoon poised over it, not wanting to destroy its perfect formal beauty. She brought the spoon down and scooped out the tiniest bit off one side. The spoon went through it like hot knife through butter. It melted in her mouth and she pushed it up against the roof of her mouth with her tongue. It could very easily have been the devil in disguise but she really didn't give a damn and smiled softly at the thought. She closed her eyes to taste it and when she opened them again, Sister Alice was looking at her, slightly shocked. She took as long as she could over the pastry.
'You look happy,' she heard Sister Alice tell her. It sounded like an accusation. She didn't care. Maybe it was slightly orgiastic but Sister Mary Teresa didn't let that bother her. After all, all that was born lived only to die. And she was no different.

They exchanged stories and found that they were neighbors in the state. Sister Mary Teresa was from Kottayam and Sister Alice from Changanacherry. They called for a rickshaw, giggling and out of

breath like schoolgirls. People stared at them. Sister Mary Teresa saw a boy standing and looking across the traffic. He had soft curls framing his face and looked like he was trying to remember something. Aquiline, Sister Mary Teresa thought of his nose, in recollection of a Mills and Boon she had read a few light-years back. He wore a black t-shirt that had a picture of His Holiness surrounded by smoke. The Pope Dopes, the legend under it said. He looked like he hadn't slept in ages but that didn't take any of his beauty away. There was something strange about the jeans he was wearing. One of the legs was torn along the seam up to his knees but was fixed with canvas rope that crisscrossed crazily and ended near his ankle in a sailor's knot. He didn't look like he felt the world around him. A silver earring hung on one ear. He looked ethereal, standing near the sea of traffic. Sister Mary Teresa felt like he had found something she never would.

Sister Mary Teresa pointed him out to Sister Alice who made her put her hand down. She chattered mindlessly.
'Looks like he's in love, doesn't he?'
'Don't be too sure. He's probably on drugs. It's Mumbai, you know. You can't trust any of the young people here. Not even the ones who come regularly to church.'
Sister Alice sounded brittle and dry as if love were something she never talked about in public.

Sister Mary Teresa felt chastised and didn't say anything after that. She felt like crying and wished for the millionth time that her father had been rich enough. Jesus Christ was never around when you really needed Him. She wondered what Italy would be like. She had to leave the next evening after the formalities were done. She had never been in an airplane before. She wondered what flying would be like.

spoonful of grey

~

My hair smells of Citrus Sunshine. My skin of Sea Kelp. Faint, fresh smells. Lingerie is so important. Lingery, as they say at the kitli. My bluejeaned legs look great. Smooth coffeecream legs encased in denim faded to the color of the sea. The sky, maybe. It's so quiet in here. Only my dressing up sounds. No watch. Why waste time? Black strappy, sparkly, high-heeled sandals. No bag. Wallet. Mulberry silk shirt straining against my chest. I'm not showing my collarbones. Come to think of it, I'm not showing anything. Except for the chocolate colored V at my neck and the strip of bare belly. There has to be a strip of bare belly. For the pierced navel, see? Not too much. Not too little. Chanel reminds me of Sara. I wear Versace Red Jeans instead. It's not as expensive but I think it's better than Chanel anyday. It's probably not even Versace.

I lounge to Satriani till the doorbell rings. I know Rohan thinks I look good enough to eat when I open the door and he sees me. He kisses me and we could be making love right now but I don't want to and neither does he and we both know waiting makes it better. But he hooks his thumbs into the waist of my bluejeans all the same and I'm aching for something real. We pop the reds and the world shivers a little and grinds down to a slow beat in the time it takes us to go down the stairs. It's a stoned universe by the time we're on the road again.

It sounds like an old song but I love the wind in my hair. I've never had long hair and I feel sorry for all those who have never had the breeze kiss their scalp. I also love this rutfutty Yezdi and the back of Rohan's neck. He's so fragile I could kill him. I love everything about Rohan but I don't like him much. I hate everything about Sara but love her. I think I'm impossibly stoned. He's got long Cobain hair and a three-day stubble. He thinks it's cool not to smile. I don't think I care. I'd like a cigarette right now. He stops by a park bench while I light a London. Why would anyone want to sit here? Maybe on the way back we'll sit here and watch traffic. If we're drunk enough high enough low enough. I have a bomber joint in my bra. Pure Afghan. He'll flip when I show it to him in the loo. That's the only reason it's in my bra. Got to make him flip.

We're there. Old Avalon holds her neon arms out. Arnab and Jamie are waiting for us near the entrance. I like Arnab. He's uncomplicated. They're happy and gay without the lacy shirts or the manicured nails routine. They're macho gay. Some of my best friends are macho gay. Jamie likes my new jacket. He fingers the fake fur collar and the satin lining. Rohan and Arnab pay and all of us get stamped by the bouncer and walk in.

The thing with chemicals is that it reels in and maximizes selective perception and makes the little pieces of the jigsaw beautiful to behold. We've been here for an hour and there's been good music. Not great. But good. My mouth is dry from too much nicotine. Jamie and Arnab have disappeared. I think I'm drunk. Rohan definitely is. He's playing the matchstick game with himself. I leave him and walk around drinking and watching the cool people chill. The coolies, as they say at the kitli. Everybody is wearing clothes that hurt the eye. Well, almost everybody. Two people, I think they're women, are having a heated discussion about Vivek Oberoi. Why would anyone want to discuss Vivek Oberoi? A bald man on a barstool spills beer and looks around to see if anyone saw him. He doesn't notice me. There's an aquarium that runs the length of one wall of the bar. The fishes look drunk. They would. They're walled in for eternity. The aquarium thing

has small purple gravelly stones on the floor. A wall of waters pretending to be the sea. There are plastic divers and castles and mermaids. Bubbles of air. Such an effort. Goldfish. Angelfish. Guppies. Hootie and the Blowfish. It's a jungle out there. They look like they're laughing behind the wall. They float around and kiss the glass. Or clear plastic, maybe. My fingers are numb. I can't even feel my own skin. When I tap the glass with my finger, they flee. I don't know how long I've been playing around with the fishes when I feel an arm around my waist and someone kisses me on my cheek. It's Tito. Lawksamussy. Maybe he's DJ tonight. No wonder I haven't heard any boybands. I smile brightly. He's stoned immaculate just as I am. It's in his eyes. He gives me the head-to-toe lookover and steers me by my elbow towards one of the loudspeakers. It's too loud and I can't hear anything he's saying. He takes the hand holding the cigarette and we stand in the niche behind the loudspeaker. The noise disappears as if by magic and so does the crowd. Tito shouldn't have left the console. Some idiot plays Iglesias. Tito has greygreen eyes. I know they're not contacts. It's just some Portugese blood. I don't know what he's saying. All I know is that I'm floating and I wish he'd stop talking. He's a fucking naked talking head. He pushes me against the loudspeaker. Gently does it. It's taller than I am. The naked talking head kisses me on my mouth. Wonder why. I can feel his palms against my waist. His facial hair is too up close. If I throw up now it's going to be a funny movie. A fuvie, as they blah blah blah. His hands are warm. The loudspeaker is pulsing and I'm buzzed. I can feel the bass vibrate through my body. It starts at the small of my back and runs up my neck and down my legs. It's the color of honey and I'm bathing in it. I could make love to anything right now. It may be bad music but bass is bass.

I push Tito away. He doesn't taste right. He tastes drunk and his mouth is too wet. Funny to think that if he rapes me right now it would be provocation. I don't have to try too hard. Push doesn't get to shove. He keeps saying sorry. He's wasted.

I go to the loo and fix my face. My face is falling. I smoke a quiet cigarette. I don't feel like going out. I feel lost and I'm aching again

but I don't know why. It's a good thing I wore waterproof lipstick. Smile. I toast the mirror and down whatever's remaining of the drink. It's gone flat. It's turned into Langolier beer. I wonder if Rohan's still at the matchsticks. There's a knock at the door. Think of the devil. He figures I must have passed out. Ah, Concern, that old friend who never fails. I pull him in. I sit next to the washbasin and he stands in front of me. His eyes keep going to the mirror behind my back. I wrap my legs around his waist and we talk for a long time. I take the bomber joint out of laced cleavage and get the reaction I expected. We light the joint and watch the smoke we blow being sucked out by a tiny but powerful exhaust fan. It's better to watch smoke if the air doesn't move. You can watch it curl and ballet. The exhaust fan has destroyed sublimity. He smells my neck where the perfume is the strongest because I know he will. He buttons up my shirt so my bra can't be seen. I tell him that the floor tiles are blue, the throne is blue, the towels are blue, the wall tiles are blue, my bra is nightblue but still blue, my toes are painted blue. I tell him that it's a b-l-o-o. He looks at me like I'm Norman Bates. We stare into the reflection of the lightbulb in the bucket of water. He kicks it gently with his foot and the water ripples out like a minor earthquake has threatened. The light dances crazily on the water. Dancing fantasies. We have a bombed conversation that's like a blowtorch working on my brain. We're going nowhere but we laugh a lot and watch the light in the bucket some more and talk about white light and yellow light. White light is for hospitals and yellow light for the living. Purple light is for sex. He could be cheating on me. Why should it matter? I tell him I like his hair. He kisses my breasts through silk and lycra. I want to cry but it would be crazy. We pop more reds and the world is a fast spin by the time Rohan opens the door and we walk out. The women who were discussing Vivek Oberoi are waiting outside. They give me disgusted looks. I tell them not to use the towel because my boyfriend wiped his dick on it. Rohan laughs and I join him. We sound hysterical. They look at us and know that we're clinically insane. They look shocked. These are the same people who read in the daily newspapers about nuclear weapons being stockpiled and blink and go on with their lives. Shudder me udders. It's a neon world outside the

loo and my eyeballs will probably have a phosphorescent glow by the time I'm out of this place.

We get on the dance floor and start sweating it out. My body is doing things on its own, I don't know how. Tito sees me through the glass of the console and waves at me. I wave back. No regrets. He plays Break on Through and then Twentieth Century Fox. He's seen us dance. He knows we rock the floor with Morrison. Rohan is touch-talking with me. He doesn't know I exist and we spin through life. As always, people have slowed down to watch. I catch glimpses of Tito over Rohan's shoulder. He smiles. Maybe someday I'll find out what he's like at loving. Rohan tells me that I'm his sexy Mexican maid. He sounds breathless and beautiful and I love the fact that he loves my body. I'm falling. I'm fell. Neighbor's envy.

~

It's quiet as a corpse when I open the door to my apartment and we walk in. It's the twentieth floor and I'm a rich girl so there's a good view. The breeze always smells of the sea and faintly of sewage and dried fish.

He fiddles around with my music and ends up playing Rush. He always ends up playing Rush. I undress but after I take all my clothes off I pull my sparkly heels back on. Rohan looks amused. He's stretched out on the bed barechested but his pants are still on. That's my part in the play—taking them off. I walk across the room on my glittering feet and switch off the light. There is complete darkness for a moment but Rohan puts on the lamp next to the bed. It throws purple light around and Rohan is lying in a pool of it. Rush sounds like ghost music. I can hear Neil Peart come in from far away. It's a big window. I see the whizzing lights of the traffic before I bend my head down to kiss his neck. He's always so gentle, I almost feel guilty about the afternoon. I had to teach him to make love to me. It makes me feel infinitely old but at least he's got good technique now.

I play my part and he kicks his clothes off. I like the smell of Cleopatra on him. He's been using it ever since I told him it's good for dry skin. Doesn't smell the same like it does on me. I'm on top only the first time. After that he flips me over and I'm on my back looking up at the ceiling fan spin, feeling him lick me. It always amazes me how you can see through the fan once it starts spinning. It makes me believe in time travel. He's got his palms cupped around my heels and his thumbs linger at the enchanted straps around my heel. I close my eyes to the fan and wrap my legs around him when he comes up. He tastes of me. That's pure DNA. He's got me inside his mouth. I can see my ankles sparkle in the nightlight of the lamp. The third time he takes them off and rubs my feet. I feel so tired. I've been making love since afternoon. But we don't stop till the CD plays itself out. We don't always come together. I still like making love to him. It always feels like some kind of lesser magic.

Rohan has an arm around me and is already sleeping. I smoke and look out at the sky. I don't see any stars. I've never seen a truly black nightsky in Bombay. It's always prussian blue. Must be the smog. I don't move too much. He's in that place where he feels like he's falling. I might wake him up to the truth. He'll leave after breakfast and I'll be late for work. I'm good at what I do. I can be late on Mondays with such impunity. I make sure he's fast asleep before I move his arm off me and wash up. I can never sleep in the nude like he does. I feel too cold. The first time I met him I showed him his name on Tolkien's map. He was so damn kicked. Now he always puts the diacritical mark above the A even though no one ever calls him Rohān. An affectation that will probably disappear from his life when I do. He has turned in his sleep and I get under the sheets and spoon with my back against him. At least it feels like we're going in the same direction. There's some poem that would describe us perfectly but I forget what it is. He puts his arm around me again. I can feel his skin through my clothes. My veins are jumping. The price I pay for an adrenaline rush.

I'm getting used to this. What will I do without both of them? Or even either of them. I feel infinite today. Infinite.

fell

~

Joseph pissed on the rosebushes after the show was over. He had waited for everybody to leave so he could have this moment to himself. Besides, he was dead drunk. The doorman pretended not to notice. Joseph had put an arm around his shoulder, called him dwarpal, and slipped him a twenty. The usual covers had been played and there had been the usual random calls for Linkin Park and the very drunk had headbanged when the band played Battery. He was about to get into his car when he saw the girl standing under the streetlight. He asked her if she wanted to be dropped home. She got in and told him that she was called Natasha.

He was relieved when she got out of the car and he was left alone. She hadn't asked him for the lift. He had offered it. He drove back home with the windows down so he could get rid of the cloying smell of her perfume. She had made him feel uncomfortable and the silence had been too much to handle after all the noise. He had already forgotten her name. He parked and was about to lock the car door when he saw the bag lying on the front passenger seat. She had probably been too drunk, he thought. He opened the door again and leaned across the seat to get at the bag. It was the kind sold at souvenir shops in Goa. There was a Shiva print on it. He took it with him to his apartment.

Joseph spent a long time worrying over his expanding waistline and read through a couple of pages of *How A Man Stays Young*. Then he remembered the bag and looked for it. He had left it on the chair in the kitchen. He stared at it for a long time before he decided to go through the contents. It didn't have a clasp or a zip. Nothing too interesting. Telephone book, lipstick, another telephone book, cellphone (she would miss that no matter how drunk she'd been, he was sure). His hand brought out a notebook covered in blue wrapping paper. He opened it.

this diary belongs to natasha kelson. its in the wrong hands if youre reading.

Natasha—her name came back to him. Well, Natasha Kelson, sticks and stones and I will certainly read your diary, Joseph thought. She had a funny way of writing. It was all in black ink. No capital letters anywhere. He turned the page.

7/07

tried to call up sonu today but ended up dialling karans number. a year no two years have gone by and I still think hell come back. its not impossible to separate sex from love.

9/07

karans face is fading. its like the memory of a movie. I have to. it has to be so. shitty shitty bang bang lulu now lulus gone away now whos gonna bangbang now lulus gone away now lulu had a boyfriend. its highly possible that Im obsessed but I dont know it yet.

11/07

Ill change my name. I wish I was called something exotic. estelle or deirdre or something. no. let it be. sonu taught me to make origami swans and flowers. theres an orchid in a glass bottle on the table.

feel too lazy to do anything. painters block. very colorful. ennui. been this way for years. life is such an exhausting thing to try spending. like discovering the biggest rock of crack in the world and trying to make money off it. cant use it yourself because you gave it up too long back. gather ye rosebuds but what if there just aren't any. even rosebuds become too much after a while—what will I wear? too bad no fairy godmother around. will just have to go in vsop blue jeans and the expensive silk shirt and the more expensive scarlet coat. who cares I never had to pay for anything ever. have the junta oohing and aahing and pecking at my feet cant stand it anymore—that book is so very useless all art is and been dreaming and dreaming and dreaming only hold the book up so it seems to myself like Im doing something—too many buildings around. too many skyscrapers raping the sky. too many people and yet so alone. better that way instead of doing something ridiculous like falling in love and then get your head filled up with somebody elses straw. whatever it is its not here lurking in the corners dangerous to play with reality but what else in the name of fuck is everybody doing anyway. tell me zenmaster. people dont smoke because theyre so obsessed with staying alive ≈ think Ill go out for a walk been here too long. maybe even the suns going down.

Joseph got up and made himself some coffee. Natasha was interesting, if nothing else. Also lazy, going by the lack of all punctuation except for periods and question marks. He felt alive and settled down with the diary. She capitalized her Is, he noticed. The writing was uneven and looked quite mad. He turned the page again. There was nothing on it. But she had written on the facing page. He flipped through the notebook. It looked like she had written only on the pages on the right till the end of the book and then turned it upside down so she could continue to write on the blank pages on the right again. This was one crazy woman. He was sure that she needed help. The kind that came with a couch, and Freud or gestalt or whatever was the latest.

23/07

Im scared. I dont want to leave this place. what abt my money? will I get it? will I have to go away?

27/07

no time. no time. no time. theres no time. where is the framework? cucumbers need a frame to grow.

14/08

I dreamt of karan. every morning now I wake up after dreaming of him. I remember the details and connect the dots and wake up feeling lonely. he left. just left and I couldnt find him.

15/08

theres a cute guy with dimples in this punjabi music video. yuck. what am I thinking of?

17/08

SEPTEMBER 3000/-
OCTOBER 5000/-
NOVEMBER 5000/-
DECEMBER 5000/-
* 18000/-*

20/09

if I ever have a child Ill call it jude. I love that name. jude. I wish I was called jude.

The ink turned blue.

22/09

its happening. the wheels are turning. have you seen the bridge? my pen disappeared into thin air. btw is ok. I cant find my pen. what happened to them after californication? my pen.

I want to be a supernova. dylan is lucky. everybody wants to be a cult symbol. my life fits into two duffel bags and a suitcase. spiders. all over this place. crazy sheeyit.
5011 tue wed sun triv-gorakhpur

nice and quiet street—artificial flowers—uninteresting people ± the works. globalization is a very good thing. it means I dont have to go to a customs shop to get my shampoo. can just walk in anywhere and buy it off the shelf—patelbhai such an obliging cringing creature been there forever same as me. everybody knows him. nobody who knows him knows me. happy smiling freak him and I always reciprocate happy smiling freak me. now that I think of it take off all his hair and leave two stringy locks behind he could be peter jackson's gollum—fat parsi lady once stared at me. disapproved of women smoking must be. I could have slipped some acid into her zoroastrian falooda. watched while she tripped out. probably would go insane. wouldnt want that to happen to a nice old lady like her. quit staring you bitch was all I thought—posters for movies. prostitutes are very much in vogue now. streetwalkers very much the latest. all the kids want to grow up to become.

Black again.

found it.
we sat on the bridge. by karans bicycle baaaaaisickle baaaaaaaaisickle want to ride my bike. I sang. he rode away and I felt like in a bj thomas song.
impromptu kiss for arun before we left and he wanted to dance with me but couldnt because rana fucked up.
robert in the football field and he lifted me up sooooo-oh high. Im one lonely bitch. yallah yallah.

21/10

*karanchristopherkaranchristopherkaranchristopherkaranchr
istopherkaranhristopherkaranchristopherkaranchristopherka
ranchristopherkaranchristopherkaranchriststopherkara
everything gets boring after some time. christ stop her.*

29/11

*faang shooey. louie louie. my fathers eyes were open and dead.
two kids a dog and a pizza place. murderess. demon brother
saves him. Im a child of the corn. aw fooey.*

22/02

*happy fuckin birthday baby. I loveya. we all loveya. budda bim
budda boom.*

24/02

*peace once more. four walls of safety—nobodys going to get to
me in here. the savage beast needs some soothing. here we go
again strum the ole banjo for me petrucci my love. merci
merci this is what I live for. muchos gracias senor may you
grow more facial hair. dont you know of course you dont. how
silly of me to assume you would—strum while I put together
the most fantastic tomato and cheese sandwich. love cutting
tomatoes. so red and juicy. like murder. sharp knife cuts so
clean. should chop some onions up for later. not as good as
tomahtoes tomaytoes. too many rings have baffled
philosophers for ages. the day they figure out onions will be
the day humankind leaps in a giant sort of way. must write a
book about chopping vegetables some day. kelson on the
sublime. cheese cheese. such a graceful taste. like a woman.
cheesygreasy. toast the bread of course. a little golden and
crunchy on the outside smooth as silent sky on the inside the
heavens melt. onions go into the refrigerator. arrange the red
discs. a little salt and pepper and a cup of coffee. first bite the
best. as good as sex even better maybe. with sex you got to
think too much. could eat ten. negative. got to make sure I*

dont run to fat. would hate it. massive rolls of flesh and imagine not being able to touch your own toes. poor fat people. quite sad really. even worse if theyre ugly and fat. someone passes gas in a room and always the fat guy gets blamed for it. no one says it but they snicker just so he knows they know. spend their lives trying to compensate for being fat and ugly by being cheerful and funny. pathetic. oh look at me Im fat so? Im happy being me so what if Im fat? and then they go on with their lives and the look on their faces they manage to get after years of living with fat. dont you think Ive had enough? laugh with me if I laugh please.

<div align="right">

26/02

</div>

bonhams moby dick. sees the white whale. closer closer closer. white whale ahead. silence. hard struggle. whale is winning. twisting turning with the sea. faster. battery. ahab behind. run moby run. fight almost over. now it sounds like horses. neither will give up. whale has to win. ahab is angry. lightning. wants to try one last time. surges. thinks hell win. whale disappears. ahab on deck. bonham sweating. not over till the fat lady sings. silence.

He couldn't keep his eyes open any more. He set the alarm and woke up when it rang an hour later. He sat up bleary eyed in his bed and put his hand out for the notebook on the table. An hour later he was caffeined and nicotined but still reading. He couldn't put the book down and it never occurred to him to stop. He took it with him to the toilet and he stood reading book in one hand, dick in another and pissed without taking his eyes off the ink. It disturbed him when he came to the part where the both pages were filled with writing in black ink but was upside down on the left and right side up on the right. In some places she had taken down what were obviously class notes. There was something about people called Culler and Trilling. He had no idea who or what they were. He found a pressdried marijuana leaf stuck on one page. On another he found a perfume strip cut from a magazine stuck in the margin. He held the book up to his face and

inhaled deeply. It smelled blue, tangy, fresh but very faint and far away. He wished he knew what it was. He didn't have a single drink through the night.

14/03

she held it in her fins and they clapped when she was done. when will this pain end? it sounds so shitty when I write it down like that. but when will it end?

20/03

I threw up today and it was green. green. hotdamn. green. never seen that ever. portishead sounds like alien music today. its slow and strange and I feel like Im wrapped in peeling bandages walking back to birth. doesnt even make sense. what Im thinking doesnt even make sense. hilarious.

23/03

tamo satyas eyes are brown and kind. I dont know him but I love him. the kind of love you can feel for a scene in a movie that shows maple leaves in the fall. Ive never seen the fall. Im an indian living in the bombay city. no fall in bombay city.

24/05

having the color of blood or fire
producing heat
the small green or red fruit
grey or pale yellow powder

27/05

cathy im lost

1/06

smoke some more of the pernicious weed. so good after food. gobless whoever discovered it. should be more of this stuff. icecream cigarettes latex etc instead of a bombs and h bombs heavy artillery etc. would make the world a tastier safer

healthier place to live in and who wouldnt want that except maybe people like the french who spy on the french. damned idiots would steam open their own love letters if they thought they had something to spy on.

2/06

Im beginning to get psyched out when I have to face people. its not too weird because thats how its always been. still. still. still the waters run deep.

4/10

I havent even forgotten his birthday. baby no matter what happens you must remember everything that happened. everything. you must never forget. no matter what okay? okay. okayokayokay. I waited but nothing happened. nothing ever happens. nothing happens at all. I saw him today. I was lighting up and I saw him. I said happy birthday and he didnt even look. suddenly I turned into saint-gobain. nothing. I remember everything. so what? so what? so fucking what? I fucked this and I fucked that and I fucked a schoolboy so what so what so fucking what. baby well have a flower shop and you can open that restaurant you always wanted. well call it wits end. think about it. hi im at wits end. ha. ha. hahaha. where are you going? wits end. haha.

There was a page covered in black ink. It was stiff and crackled when he turned it. She had tried to blank out something. He held it up to the light but saw nothing. He wished he knew what it was. The next page had a sketch that looked like it was done by a three-year-old. It showed a figure standing on a curved line with stick hands reaching out at the sky. She had filled the top half of the page with as many ink stars as she could.

10/10

dont know what to write. how does one come at the decision to take ones own life though prohibited by religious law and

once one has taken the decision how does one procure cyanide? its quick. if its blitzkrieg enough for hitler its blitzkrieg enough for me. the buck stops here. always wonder what that means.

<div align="right">

11/10

</div>

bells bells bells. milkman postman. negative. could be anybody but no one ever comes here. salesman? willy loman? a stranger comes a knocking at my door. looks like my granda. fat bumbling body priest like face. like capone. violent bastard. might just go away if I pretend nothings happening. no hes got a syringe. what? cyanide? no bloody empty thats what it is. looks like Im going to be killed by this capone guy. whatta way to go. very droll. dont want to put up a fight or anything. remember with an empty syringe theres a 50/50 chance of survival. maybe hell just run after the vile deed. might just be able to get to the phone. what if he likes watching. horror horror horror. out out damned spot. okay whatever you do dont fight and dont scream. might piss him off. what about neighbors? too old. won't do a damn thing. neighbors indeed. wish I could listen to some hard boiled swing before I kiss the blue skies goodbye. such cold hands. looks confused. wondering why theres no screaming or fighting Im sure. doesnt even look mad or anything. will they find the remains of the last supper? there will be an autopsy for sure. the ideas one gets after reading too much. ask for some excitement in life and this is what you get. mama told me be careful what youre asking for my dear just might get it—carpe diem salesman. such cold hands. eyes like dead fish. wont have to wonder what to wear now what to—

<div align="center">

∾

</div>

That was the last entry. He shut the notebook and stared at the cover for some time. She was neat. The sellotaped folds inside were perfect. Joseph looked out of the window from his bed. It was early dawn. He

had time to sleep for a bit before he left. He set the alarm again and fell into exhausted, dreamless sleep. It was like he had listened to black noise the whole night.

~

Joseph rang the doorbell and waited for it to open. He heard the safety latch slide. It was the fourth door that he had waited for to open. Her face peeped out. She looked like she hadn't slept too well. He held the bag out to Natasha. She looked at him and he couldn't bring himself to meet her eyes. She knew in that instant. He saw it. It was like a cloud had suddenly shadowed her face. He asked her if she'd like to have lunch with him and she let him in. She told him to wait and then he heard the sound of water and knew she had gone in to bathe. He sat on the couch and looked around the room. The walls were bare except for a painting done in olive and blue. He stood up to look at it closely. It had Kelson signed in charcoal in the corner on top. She came out dressed in a camouflage t-shirt and chinos. 'A strong smell of turpentine prevails throughout,' he told her. She looked at the painting. 'LSD,' she said. Joseph nodded and felt like there was something of the hospital about the room. He wanted to get out of there soon as he could. He wondered how she'd known about the quote.

He saw that she was severely beautiful. Crewcut hair and mannish clothes. A face made up of clean, sharp lines. She had the bag slung over her shoulder. She didn't look like she was carrying it at all. But the bag looked like it didn't belong anywhere else.

They went to Karribea and she ordered prawns. He tried to talk but didn't know what to say. She didn't help either. She didn't look at him and concentrated on eating. He paid the bill and drove her back to her place. He felt the hate from her come out in waves. It filled the inside of his car. Joseph wanted to tell her that he had liked what she had written about rap being the black mans answer to white mans talk. How it was language twisted so the white man couldn't understand

his own tongue. He wanted to tell her to forget Karan. That the guy wasn't worth it. He wanted to tell her that he thought she was beautiful even before he saw her. He wanted to ask her if she had found a place to stay. He said nothing.

She got out and banged the door shut. She leaned in at the window and looked him straight in the eye. 'I hope taking me out to lunch made you feel better,' she said and walked off with one hand in her pocket.

He was left with his hands on the steering wheel. He stared straight ahead at the road for a long time and then went back to where he once belonged.

nightwatch

The cat tried to clamber up the loose brick wall. He was amusing himself with a butterfly he had found among the crumbling bricks. The wall didn't make much sense but it was there. For better or worse. She had been watching the cat for a long time. It had been a noisy day. They were tarring the road. Dusty men and women carried the stuff in tin pans on their heads. They went about checking the evenness of the road. A fat roadroller laid flat the black tar or asphalt or whatever it was. The neighbor's kids, quiet for once, squatted by the roadside in little groups and watched in silence as a shining, new road came into existence right in front of their eyes. They didn't go in even when night came and the hurricane lantern was lit and hung from somewhere on the roadroller. The light from it coupled with the ghastly sodium glow of the streetlights and made everything all the more fascinating in the dark. The dusty people went about finding and fixing mistakes. They looked like searchers at a flying saucer crash site.

She couldn't see the cat or the garden anymore. It was too dark. Outside the gates the world was so busy but she had been left to herself the entire day and oh it had been delicious. She hugged herself because she had a small fortune and she could go anywhere she wanted to. She could disappear if she wanted to but she would leave a

note, of course. Going away was one thing but going away never to come back was another. She wasn't coming back, no way, but what if her mother died and they had to let her know. She couldn't bear to think of missing the funeral. And she loved her mother. Maybe someday she would come back for her but not today, not today, not today. She thought of Taslim and grinned to herself in the dark under the roof of the verandah. The roadroller roared outside. He was circumcised and she had almost laughed when she saw that his balls looked bruised and blue. It hadn't felt like the first time though it had been.

The dusty people went away and so did the roadroller but she still sat out on the steps with her knees pulled up close to her chest. The stars were out and she looked up at the light that came in from the past. The cat came and curled in and out between her feet. She patted him absentmindedly. He yawned and stretched his claws out at her. She thought of Wolverine. The gulmohar put its deadwood fingers out at the sky. It stood starkly outlined in the alien light that came in from the world outside. It had been bright as a flamenco dancer only a year back. Then the rot had set in. It was so beautiful she could cry.

She went in and poured out wine into a papercup. She lit the last cigarette before she left and smoked it while she had her drink. She walked in and out of all the rooms feeling goodbye.

≈

The train started moving away and it was as if the wheels were running in her head. It was a relief to leave the noise of the platform where it seemed like everybody had something to sell. She knew Joseph wouldn't care and knew she would come back. But not today, not today, not today.

nicholas

There's a man walking down the street and he's thinking all these people, how strange, how delightful, how absolutely terrifying. He's singing and doing a little tapdance in his head, wishing there was something to look forward to or at least something he could think about. Something that had happened in an ice age that he could pull out of his memory and slowly roast over the fire so he could watch it thaw. A night, a body, a dead faithful dog, anything at all. But there's nothing except the grey pavement under the soles of his shoes and the steady clumping of heels hitting concrete. He wants magic, an angel, a body falling from a skyscraper and crashing right in front of him. He's sad there's no amazement left.

He's struggling to keep the people off. They're trying to stamp themselves onto his body, tattoo their faces on his skin. They're watching and he doesn't want to look but does anyway hey hey whatever. He doesn't want his friends and they don't want him at all. He has rooms to go back to and he doesn't want that either. He's thinking with his head down and his hands in his pockets everywhere they're trying to sell sell sell. Sell this and that and everydamnthing everywhichway you look and there's no escaping it. Mom met dad when they were working in an airport. He swept the floors and she took the coats and one day there went his first wife and she became the next and they had him such a happy life. No problems adjusting

with his stepsister. She loved him the moment he was born gotta new brother now hey hey. Married a pastor called Dave who had a penchant for Indian chicks and now they're in Philadelphia getting fat and preaching hard and the kid's a cokehead. Beam in thy eye.

He's thinking he has such potential. He could be anything. He could direct movies. Be Scorcese, Tarantino, De Palma, anyone at all. Rubs his hands together. All right all right. Turns. The people, the noises, kids, mothers, beggars, lights. He's concentrating on his shoes. Steady. March. One two. He's doing nothing going nowhere. Buys Happydents and chews on them. Nothing's going to make his teeth white. What's the point? Use sunscreen, floss, get married, divorced. All this and after you're dead who's going to cut your nails and hair and keep you in good shape for kingdom come?

Now, a woman. That would be something. Chance meeting choice encounter and stay don't go away stay stay stay. Don't leave me. Take me. What's yours is mine and what's mine is mine too. Too many happy, shiny billboards. Buy. Sell. Somewhere by the Mediterranean Sea walks my love in a red bikini. Shakes his head. Doesn't do anything for his thoughts. They don't rattle and settle down to make more room on top like peanuts in a jar. Somewhere fairies were dancing in purple silk slippers with dragons embroidered on them. But where? Where? Where were the little people who lived in toadstools? Buried under tons of glass and concrete.

Such depressing friends. The obese one cramming himself with lard and saying nobody loves him nobody wants to have sex with him he's so intelligent but people just don't care for conversation anymore. The suicidal one saying lemme die lemme die and not even trying too hard. Four Calmpose and standing near the window screaming gonna jump gonna jump no balls to do it. Nothing left after life so why ruin a perfectly good bedcover by letting the dog shit on it? The junkiebitch saying stop next week, wait for Monday, no, next month, wait for the first of the month, fuck it all; wait for when the first of the month is a Monday, that's sometime next year.

Turns another corner. Sees girl standing under streetlight, brilliantly lit up like a birthday candle. Looks like she wants to cross the road. No, just staring at traffic. She ignores him. He slows down. She's got vacant eyes. Too many things in her head and nothing in her eyes. He stops. It could be sweet.

slide

Susan was sliding up against him. He couldn't wait anymore and slipped his hand up under her shirt. The door to the office was unlocked and anybody could've walked in. He listened to the voices outside. High, excited sounds discussing exams. She seemed oblivious to everything and knelt in front of him. He looked down and saw the pale brown nape of her neck. He tried hard to think of something other than his wife but couldn't.

Susan stood up and zipped him close all in one quick motion. She pushed her tongue into his mouth. So that's what he tasted like. There were still five minutes to go for the break to end. He sat in front of his computer and tried to play Solitaire to steady his hand. She sat across his desk, lit a cigarette and passed it to him. He took it and watched her light one for herself. She was bright. He wondered why she had to go and ruin it all by being a junkie. She put the cigarette out in the ashtray.

'I'm not attending the next class, Herr Doktor. Mark me in. Arrivederci.' She blew him a kiss and left.

Herr Doktor surveyed the class empty of Susan (bereft, he thought) and looked at his nails for a whole minute. They waited expectantly for

him to say something fascinating. He started talking about the invention of electricity blurring dichotomies. They nodded intelligently and took down notes. Just before class ended he paused for a moment and told them that a hole in the ground and a little garden was all he needed to be happy. He wasn't unlike a hobbit, he told them and grinned his wise grin with his brown eyes. He left them dazzled by his brilliance.

When he was walking out he thought he heard someone ask some else about Susan's absence. He hummed Strauss to himself and waited for tomorrow.

leave the clowns behind

~

I have no idea why I say the Our Father every morning sitting on the john. It's physically and spiritually satisfying, I guess. Early Morning Ruminations on the Shitpot. I'm probably depraved. Or that other Oscar Wilde d word. Forget what it is. Well, at least it's the least of all my depravities. Forgive her, Fader. She nose knot vot she duss. It's one of those glorious mornings that make you want to talk to yourself in polysyllables for the simple fact that it sounds good to your ear. Decadent. That's the word. Le mot juste.

Breakfast like a king, saith my mother. I'm politically correct. I breakfast like a queen. I do so on days without hangovers or lovers. Waking up with either is a bloody pain in the arse, wot? Wot wot. Wot not. I left my lover last night after wining, dining and sixtynining her. I told her very quietly that I was bored and that the relationship was turning moribund. She wasn't too kicked. But things went très smoothly. And, yes, that's all the French I know merde foutre parle vous Parle-G tomber la chemise. This morning fills me with indecent, lunatic joy. Like that of a bird let out of a cage. I blink my birdy, beady eyes in too strong sunlight and my wings are creaking. What do I do, Icarus? Tell me. You were young and you died. What did you see last?

Shoppers Stop. I walk into Habib's and it's not exactly the doors of Arden but I can walk out feeling just as gorgeous. Sort of post-colonial and post-deconstructionist too. East meets West in the fucking sun. Them and Us. I and the Rest of the World. They put me on a pedestal and do unmentionable things to my body. And the man is running his fingers through my hair telling me you must take care of yourself, dahling. You must. These split ends just gotta go. A man's got to do what a man's got to do. I tell him I want a Sinead O'Connor cut. Take the whole goddamn thing off. Whatever's left of it anyway. He loves it. I'm livin I'm livin.

Icarus tells me that fear of the sun musn't stop us from flying. One must be a fatalist to survive, he says. If you fly and succeed, well, yippee and other Yankee exclamations of the sort. If the glue melts and your feathers come apart at the seam there's no place to go but down and if you're dead, it shouldn't matter much, should it?

I walk out feeling like I could run up a mountain. I probably will. The long forgotten joys of picking out clothes that make my skin sing are mine once again. I feel benevolent enough to blush at the people staring at me. The smile on my face must look like the unmistakable leer of the imminently insane.

I have coffee with no one for company and revel in thoughts of vainglorious suicide. It could be anything. Sweet. Enchanting. I buy fresh vegetables and potatoes crusted with mud. Lots of pesticide I'm sure but they are alive under my fingertips. Not like the frozen food kept on life support in supermarkets. The colors are mad and strawberries are expensive. Scarlet and surprisingly fleshy like the nightlips of a woman seen under strobe lights. I feel an infinite sadness for Sara who doesn't want to fly. I know she will always remain with me like the edges of a long forgotten dream. I can't help being faithful. That dog word again, to Rohan. In my own fashion. I love him as he loves me. We are disenchanted people who have been loved by too many. And now we have this, not caring for sunsets or light-dappled foliage. Irrevocably entangled in quite ordinary lust.

And I will not be surprised, Cynara, if you throw my heart away to the wolves to be torn apart while red blood spurts and breaks the monotony of the white snow. I will lose you to the Ice Queen. I don't know why I feel this strange need to think bizarre thoughts. Everything else remains ordinary. I know what he'll say if he ever finds out. He'll do a Bruce Willis. You cheat good. You cheat good, baby. And then he'll forget to light the cigarette. Get naked, that's what you're here for. I've always wanted to tell him that.

I call up Arnab and tell him come over and bring the dragon drugs. I draw the curtains and let the fishybreezy air in. The sea cleanses my house of accumulated corruption. Soup and later, cheap red wine. Can't eat too much. Not with the dope that's on the way.

I haven't talked to Arnab for so long. We always use dispos. He breaks the needle of each one after we're done. We talk about Jamie. Arnab says he won't live much longer. I think otherwise. He likes the Minestrone. I can't taste the food. But I eat it anyway. We listen to anything that comes in our way. He likes hip-hop. But we're old school at heart. I tell him that Dave Matthew and Stefan Lessard together sound like waterfall. He tells me I dunno man I'm stoned, no, I'm jammed, I'm bombed, man. The problem with Arnab is that he can't channel when he's like this. The secret is to hold on and stop scattering. Keep the windows open. We talk about sex and laugh like crazy. He tells me he's writing a book. It's going to be called *Life Is Fucked*. Christ. I like what he writes, though. He's written loads of poems. He forgets them after the trip wears off and he gets normal again. I think it's amazing. Pure genius. We put our hands over our ears and close our eyes tight. You can hear the sea and see the universe if you do that. It's an old stoning game.

He stands up and starts pacing. He stands completely still near the door for about an hour and then asks me what he's doing there. Like I'm supposed to know. I feel alone after he leaves.

I take gateway paper and charcoal. My hands do the rest. The real sketches will come later. I like my footage raw. The director's cut, so

to say. The necklace that will be is Sara. It's a fire-red countess not allowed the luxury of self-combustion. A sea blue sapphire will dampen but not put out my countess. They all live in a platinum palace that costs more than all the gold in the world but has no resale value. Sad but true. The boss is going to love this. Marriage season approaches on horseback. This will be snapped up soon as it's out.

The window has framed a Fabergè-egg blue dawn when I look up. I know now that I cannot be lost. The sea, for me, is not an amnesia-producing body of water. But it kills. I grin foolishly to myself. I feel a little like Odie, who reads Tolstoy and listens to Mozart, when Garfield and Jon are not home.

It's going to be awfully dull now on. Days will fall like leaves. I want to be in Ireland. Anywhere with green, rolling hills and damp in the air. It's too hot here. I'm tired of thinking. Rohan will be here soon. I don't know how to tell him I don't need him. Or anyone else, for that matter. People want to be needed all the time. It's exhausting.

victoria

~

There's a woman walking down the street. She's thinking all these boring people with their boring lives and they're probably thinking the same about me. She's thinking the star life should be for everybody. If not forever then at least once in a lifetime instead of being part of the machine like this. Get to know what's it's like not to be poor, diseased, travelling on buses, listening to the Walkman bad quality sound can't ever hear the bass too well CD's are so damn expensive.

She stops and looks at mannequins in the display window. Neon skies and everybody living the plastic life breathing plastic air wearing eating shitting plastic for all you know. Maybe they're not mannequins after all. Maybe they're real people trapped behind glass after having their souls sucked out through their eyes while the mannequins are walking free outside. Maybe that fat man who looks like St. Francis is just a mannequin gone fat. They're everywhere taking over the world.

All these stone cold sober people looking, dialling, chatting, surfing, searching, drinking, injecting frantically for love. So scared to be alone. So scared to die. Such a horrid thing that parents eventually die or children do and all of a sudden it's a big black hole. The dead end up in the Great Big Black Hole in the Sky. That's why all these dreams about light and tunnels. No one's getting out. It's just the light getting trapped

and racing in to smash you awake. Well-lighted restaurants with potted palms and orange interiors you could see from outside were the worst. See everybody's face down to the last wrinkle to the dirt on their shoes when they sit in that posture with their legs out crossed at the ankles and hands locked behind head leaning back pretending to relax. All the hindus, catholics, muslims, buddhists, protestants—all hating each other secretly and secretly scared to admit that most of the time they thought God was all bullshit, brinjals and great big balls of holy fire.

She's dressed in red with a crazy diamond shining on her the light following her footsteps while she walks to the man who will waltz and tango with her all the way to Mexico way but, of course, she's not. She's just a beggar riding the wish-horse really. In reality, nothing happens at all. She turns and stops and walks and stops and walks again and stops. Now, traffic. That's something. Left hand in left hand out left hand in and shake it all around. Work. Home. Work from home. Jog to the supermarket for an enormously healthy lifestyle. Live to be 90 without a day's work. Clatter clatter. Too noisy.

Such uninteresting people. Boy and girl on bike and he's got an arm around her and is constantly running his thumb over her lips but she's still talking like it's so natural yak yak yakkity yak. What do lovers talk about? Nothing at all, dearie. They love and love and then love no more.

She's thinking streetlight spotlight what difference does it make? Man across the street shuffling along but secret spring in his heels. Springheel Jack. She looks and ignores. Slowing down. Stops. He's looking at nothing. Still, there's that thing. His shadow crouches and prowls while he stands still. Common as blood. Natural as murder.

For some time there's a wall of cars between them but they don't know it's a wall and they don't know they're they yet. She thinks she knows but she doesn't. He does but doesn't really want to.

When the traffic lights turn blue there's no choice. He is startled when she turns and starts walking to him. It could be sweet.

bearded rainbow

Susan looked at herself in the mirror over Herr Doktor's shoulder and wondered what exactly she was doing here with this thin, dried-looking man bursting at the seams with intelligence. It was a weekday and the nightclub stuck to old faithfuls. They played INXS and Herr Doktor looked at her over the neat scotch he held. He raised his glass. 'To you, Susan.'

She mentally squirmed. She could have picked anyone. What had made her do it? Maybe she was rolling over into the country of the insane. All he had on his side was age and a Ph.D. She smiled brightly and tossed her little girl bangs, very aware that she was tossing them. She felt like she was in some surreal snuff movie. Any moment now she would be found dead by the sea with nothing on except a scarlet ribbon tied around her wrist. The boy at the next table was eyeing her. She laughed inside. They were all playing the same game. Herr Doktor had put his glass down and was still looking at her. She looked down at the water rings on the table.

'Why don't you dedicate a song to me? Go ahead. Do it.'

She thought she'd blow up in exasperation. She was sleeping with the jerk so she could take a break from the soppier boyband type. Why did he have to go and spoil it all by acting as if this mattered? She hated men who drank scotch. The nightsweat was unbearable. She wondered how his wife had managed to stand it for so long.

'Okay. The next one's for you.' She gulped down her drink. 'And since we don't know what the next one is it'll be a surprise.'

He rubbed the back of her hand with his palm. It felt like cold sandpaper. They played Purple Stain and she threw her head back and laughed when she saw the look on his face. She felt better. This was going nowhere. Tomorrow she'd tell him that it was all over. She excused herself and went to the loo.

Susan stared at her face in the mirror and took off the sweatshirt she'd borrowed from him. It had been cold when they came in but she was sweating now. She took out the small mirror from the backpocket of her jeans and the tiny cellophane wrap of coke she'd hidden. She laid out a neat white line and snorted it with the straw she'd jacked from the table without Herr Doktor noticing. She saw her nostril in the mirror when she bent her head down. It looked quite horrid. She waited for the hit and wrapped the cellophane neatly and put it back between her breasts. She flushed the straw, put the sweatshirt back on, the mirror back into her pocket. She stepped back into the world and saw Herr Doktor from a distance. She felt divine as she wound her way through the tables to him. She rubbed nervously at her nostrils to wipe out any faint remains. He had completely freaked out when he'd caught her at it once. She hated scenes. Why couldn't people who didn't want drugs leave the people who did alone? No. They had to make laws and outcasts and generally make life miserable for anyone who was different. Why this fear of drugs anyway? They sold cigarettes like they sold water and no one complained.

She sat down at the table. He was about to say something but she shushed him.

'Don't talk. Just listen and watch. You're living in a circus, don't forget. Don't talk.'

He didn't. But he put a hand on her knee under the table and Susan felt a wave of repulsion for the pathetic unhappy man in front of her. She looked at the back of his head in the mirror. He had a beautifully shaped head. That was what had drawn her attention in the first place. She ordered a Screwdriver and waited for it. He patted her knee and brought his hand back to rest on the table.

~

They went back to her place. He liked it. He liked the peeling posters that screamed the 70s and the books that lay scattered everywhere. He'd searched in vain once for a book prescribed for the course. It was very quiet in her room and she sat very still on an armchair next to the window. He walked to her and sat down on the floor in front of her with his head on her knee. Susan felt faintly ridiculous. He reminded her of her grandmother's poodle. She did to him what she had done to the dog. She ran her fingers over his head. His hair felt soft and prickly. It was cut so close to the skull. He breathed in the soft smell that was so irresistibly close.

'So where's Fraulein?'

He didn't answer for sometime.

'Out of town.'

'Achtung baby!'

He kissed her thigh. He wanted to see her studded navel and she let him.

Susan insisted on the lights.

'All the better to see you with, my dear.'

He felt old when she ran her fingers over his ribs. The fact that his hair had started to grey everywhere had had her in splits the first time. It was still amusing. She chuckled.

She fell asleep while he was talking and he lay awake looking out of the window for a long time. He saw the landing lights on three airplanes before he too went to sleep.

He got dressed without waking her and closed the door gently behind him. It was still early dawn. He had to go to the station to pick up his wife. He raised his hand to his face and found he was smelling of her. He should've had a bath. He looked forward to seeing her in class in two hours time. Fresh, laughing and smelling of something heady and Christian Lacroix. He would ignore her while he taught and she slept through the class.

He liked watching her talk to her friends. It looked like everyone wanted a piece of her. He knew for sure she was dating, in all possibility sleeping with, the tall vain-looking boy with brown curls never seen without his guitar case. He didn't know his name but had seen them one evening. The boy had had his hand stuck deep inside the backpocket of her jeans. They had been taking a walk near the football field and hadn't noticed him pass by. It shouldn't have mattered but it had saddened him for a while. He didn't think he had any right to ask her about it. If there was anything Herr Doktor prided himself upon, it was discretion. The hour passed without any major troubles and Herr Doktor said goodbye to his wife and kissed her on her cheek when he left her to go and open the door to his office.

coda

blue monday morning

~

If you're going nowhere
any road will take you there.

George Harrison, *Any Road*

It's nice to have known love. Classy, too. Like a Duesenberg. Gleaming on the outside and only a name on the inside. And the name so small you wouldn't know until you looked under the hood. It comes and goes like the memory of sunlight. I believe it's impossible to have had footage of when they put a man on the moon. Mostly because of an RHCP song.

Always it has to start in a café. In the evening when there are people coming and going and making polite noises that mean nothing. Forced talk and laughter. They don't know it's okay if they don't talk. If they remain quiet. They won't. David's asking me if I'd like Tiramisu. I like these foreign sounding names for food. It feels different going down your throat. I'm wondering that for a Hindu country I sure know a lot of Catholics. Means nothing, I'm sure.
'Yes please.'
Poor chap. Can't understand why I'm not talking. Written all over his face. Say something. Say something. Anything. It's entirely possible

that I do not have feelings anymore. For people, that is. No feelings for people. Except, maybe, sometimes when they're all talking at me and I don't know what they're saying, so I cry and they end up monkeypuzzled. David's looking around. Fidgeting with the paper napkins. Bored.

I make an origami boat and give it to him. He smiles. So I make a bird, then a lantern and then flowers and give them to him one by one. His smiles are fading now. Artificial flowers are intriguing. Are they art? Must be. Imitation of life and all that. Kin to photographs if you look at it that way. What about a photograph of an artificial flower? Sometime in the future there will be no flowers on earth. No daffodils to think about when in a pensive mood. Nobody cares. They say she can't grow up, can't stop drugging herself to death, drinking, smoking, will be dead before her time. Referring to myself in the third person. A most irritating habit.

He tells me I'm beautiful. David thinks I'm beautiful. Now that's a scream.
'Why, thank you very much, David.'
He's pleased. So very pleased. Knows how to treat a lady. I want to get out of here. Go to someplace where there's a dazzling blue sea and I can wear astrakhan coats and fur caps and sparkle at night. Step down from a black limousine and walk past people who'll always remember the perfume I left behind. What are astrakhan coats? I can only think of something really rich, warm, the color of ashes and not like tweed. I can't feel the cloth under my fingers when I think of it. I can if I think of satin because Rohan had satin sheets on his bed. What is David going to do? Will he gladly pick my pieces off the floor? Will he sweep me under the carpet? I tell myself don't break so easy, don't break so soon, there's so much more to crash against you in the times to come; how will you live if you are to break so easy, break so soon? And, somehow, I don't cry. I just feel like a dork thinking dorky things.

I sit still in this stupid café called Cakewalk and try to tune David out. He's telling me how bad his job is. He works in a call-centre and has

to put on an American accent all day or night or whatever unearthly hours he works. I suppose it must be spelt center since it's American. Two sets of spelling rules for the same language. The Sumerians would never have done it. He says most of his friends work there. It's a regular party, he says I want to drench him in lighter fluid and watch him go up in flames when I set a lit match to his head. Why is he like this? This David who has such a horrible time at his job and calls it a party because he has his friends around to share his misery. He sits there talking about it as if it were perfectly normal. God damn him.

I tell David let's play games with the faces. He has no idea what I'm talking about. I have to explain it to him very carefully, like to a four-year old. You can play lots of games with faces. There's the Animalface Game, the Birdface Game, the Insectface Game, the Famousface Game. The lady with the pink skirt, for example, is a fly. She's got huge glasses, a big forehead and a small pointy chin. She's sipping Coca-Cola through a straw and doesn't look human at all. She's looking around like she's blind and can see only compound images with her insect eyes and no people. The fat guy attacking his food looks like Bappi Lahiri. Gold ring, expensive clothes—definitely a Bappiface. The woman in the hat (!!!) looks like she's trying to do. What? Eva Peron? Failing miserably. Besides, what kind of idiot wears a hat in India? Only firangs wears hats. The queen wears hats. It's just not done. David says stop, stop, okay I understand—I don't want to play any games—I don't want to do this. Why is he so cheesed off? I was only trying to keep the conversation going. He shakes his head and runs his fingers through his hair. Exasperated. I pay the bill. He says, 'No, no. I'll get it.'
'Fuck you.'

Not that I like using bad language even to myself but the situation just called for something drastic. Anything to wake him up. I don't know how to get rid of him. I get into a rickshaw and he gets in next to me. Wants to drop me off home or something, I guess. I love rickshaws. An anonymous driver who will have nothing to do with you once he gets

his fare. The meter is turned on and the white-on-red FOR HIRE sign is upside down. The minimum fare accelerates so fast. At the traffic lights when the engine is idle I can hear the loud ticking of the meter. It's the color of steel. I read what's written on it. Super Meter Mfg Company. 59 B, Mundhwa, Pune 411036. Maharashtra (India). Some rickshaw drivers adjust their rearview mirrors to passenger breast-height so they can have some eyecandy while driving. Not this one. He seems decent enough. I can't hear David over the din. Not that I want to. He holds my hand and apologises profusely for God knows what. If only I could push him out on the road and get on with my bloody life. David should be careful. He brings out the homicidal maniac in me. The rickshaw drivers sometimes take the firangs for a really long ride. They take them all over town and tell them that the number on the meter is the fare they're supposed to pay. I know this guy called Colin who paid 700 to get from Koregaon to the University. The world loves American tourists. It's a pity they're getting smarter. I don't miss Bombay at all. Now I guess I'll have to invite him up for a nightcap or something. Shit. I let him pay for the rickshaw so he feels good etc. I love my little home. Come to think of it, I need David as much as I need a tumour. I mix Wallbangers for both of us. Lots of ice. Orange juice. Vodka. Stir. Float the Galliano. Exquisite.

David is fidgeting around with the newspapers. He looks thankfully at the drink I'm holding out. I wish he'd talk some sense instead of cringing around like a dog. I have no respect for him. That is the problem. Zat ees zee problemo. I can't get drunk or stoned these days. I might stagger when I walk and fumble with my words but my thoughts remain horribly screwed on to reality. Like furniture on a ship. I could be going mad. I don't know. But this is my home. That much I know. Here I am with a foreign name in a land I know nothing about. Being a little melodramatic, I am. Can't really blame the colonists since I'm half Jewish and my great-grandparents were Israeli. They were spies. Well, I wish they'd been spies.

David has finished his drink and is leaving. I don't want him to stay and I'm too scared because I don't know what to do with myself when

I'm alone. But I'm brave and I wave goodbye and he pats my back. An everything-will-be-all-right pat. Then I close the door.

I can't sleep. I can't stop thinking of Rohan. He ran his palm over my arm once and said I needed to wax. It's like jurassic park, he said. He said, Do your bloody eyebrows and wax your bloody legs and get a bloody life, Natasha. As if life is this thing made easier if you do your eyebrows and wax your legs. I did those things and David said I was beautiful and yet nothing has changed. Here I am, the same, only less hairy. I shouldn't have stayed with Rohan. Rohan told me I was a lunatic. I told him to go and wax his bloody legs. Always thinking of this body or that. In my head I'm a woolly mammoth always in love. Not too bad, even if I say so myself.

∾

Bronzè, d'allure sportive. Cheveux: très courts, châtains, front: haut, yeux: bleus, oreilles: petites, nez: mince, bouche: bien dessinée, lèvres: minces, menton: carré, dents: blanches, joues: rasées, visage: ovale, mains: soignées, bras: longs et musclés, poitrine: large, dos: large et droit, taille: fine, ventre: plat, jambes: longues et musclées, pieds: assez grands. Regardez le portrait. Charmant.

I am out on the mean streets again. The all-singing all-dancing crap of the world. It's Saturday. That means David will come by in the evening and we'll go out to some club or the other. I don't know why he keeps hanging around. I don't even like him much. He can't like me because I'm beeyootiful inside. Will I entirely decompose and turn to dust before something good happens?

I'm shallow. I know that because I could never fall in love with someone ugly, even if they were beautiful inside. J'e deteste ugliness. That makes me shallow and I'm not proud of it. David is beautiful and shallow just like me. His shallowness belongs to another category. He's *completely* shallow. I, on the other hand, have hidden depths. I have no idea where they're hidden but I'm sure they must be around somewhere. I want to stop thinking.

Sometimes I think in images and sometimes in words. It's better if it's in images. I can just push stop whenever I want to. If it's in words, I can't. They just keep pouring out in black and white and I can't stop them. There was this time when Karan came to my place very late one night and tapped on my window. I was staying in an outhouse somewhere. I woke up and tapta was outside. He said, Hey lady, walk a while with me; and I wore the bottoms of my pyjamas rolled and walked out. No questions asked. The streets were empty. Then he made me stand under a streetlight and tilted my head back so I could look up at millions of sparkling raindrops made golden by the light. Wet goldflakes falling down on my upturned face and shoulders and everywhere. We stood under it and stared up for so long. A car passed by and asked us if we needed a lift and we laughed. That's an image. Golden rain. It must never happen again because it just wouldn't feel the same if it did. There was this other time when I called up Rohan from a phone booth and he told me he was so drunk he was leaning against the wall to keep himself from falling down. Then he told me he was reading out to his friends all the letters I'd ever written to him. They were all having a jolly good laugh, he said. A jelly good laff. That's words. I can't stop those. I didn't cry that day. Didn't even feel angry. I just paid the call-bill and walked away. Okay. I'm sick of being depressed. As of now, I'm not depressed.

~

I'm spectacular spectacular in emerald tonight. A sparkling diamond. A green faery. I have David on my arm and he likes my legs. We walk in and everybody turns to stare at the shining lady and the man on her arm. Her eyes are glittering and cold and looking out at the world with contempt. That third person thing again. I'll end up old and bold and thinking of nothing but my own sweet self.

Another club, another night. I don't know about David but I'm here to watch the people. I'm always anywhere to watch the people. There's a starlet from a soap opera by the bar, surrounded by admiring rich men. Pauvre femme. Lobo waves out at me. What is it with me and bartenders?

If they had a secret organization, I'd be an honorary member. I'm not angry with David anymore. He's stupid. Lots of people are stupid. He's human and I'm human and maybe he thinks I'm stupid too. Naaah.

I want to get drunk. Very drunk. After some time I leave David and escape to the ladies. It's dim and peaceful and a very bordello shade of pink. Warda comes in. She looks gorgeous in something that looks like a bra and is a bra but isn't a bra. We hug and kiss the air and say how silly it is to act like society ladies. Neither of us have any idea what it is exactly that society ladies act like but we're pretty sure they dress like Simi Garewal and kiss the air all the time. We make up our face and she smiles at me in the mirror. I smile back.
'Who's the guy with you?' she asks.
'David,' I answer.
'David who?'
'Like I'm supposed to know. Some idiot.'
'Any good?'
'Pathetic. Awfully boring. Who're you with?'
'Christopher.'
'Like him?'
'Are you kidding?! He didn't know what agnostic meant till I told him. Then he thanked me profusely for letting him know there's a word for people like him.'
We laugh. Warda is seeing Christopher. I wonder if he's any good in bed. I like Warda. We're both good-looking women who have to tolerate some very boring men because we like the sex. I ask her to join me so we can bitch some more. Her eyes light up.

Christopher and David sit and stare around. They don't know what to talk about. Warda and I talk about sex. I say it's better stoned especially if it's not worth remembering and she agrees. David is rubbing his eyebrows with his thumb. Christopher is tapping his fingers to the music. He can't keep time. The music is really loud. They can't hear what we're saying. We tell the guys we want to go out for a drive. They don't want to because they're drunk. I'm not drunk but David won't let me drive because he thinks I am.

It's cold as ice outside. We're on the Expressway and I'm driving. Warda is next to me and we've shoved the men into the backseat. She's put her head out of the window to look up at the stars. Christopher has snaked his arm in between the seats and keeps trying to pull her back. I ask David what's underneath his deadpan face. He doesn't answer and I blow smoke out of the window. The sparks fly off my cigarette and disappear in the wind. I privately think of him as my Quasimodo. He's a metaphoric hunchback, though I really don't know what a metaphoric hunchback is. He just belongs to underdog country. I picture him up in the belfry ringing church bells like a batty rabbit. Batty rabbit, I like the way it sounds. It's impossible to talk to him. We don't share the same frequency. Like Warda and me, for example, or Rhett and me, or Arnab and me. It's just not right. Too much static. There's a camel-cart on the road. They should put headlights or halogen lamps or something on these infernal creatures. *Infernal* creatures? Where in hell do I get my vocabulary from?

The tunnel is the best part of the Expressway. It's another country. Wide, sweeping roads and places like Lonavla and Khandala where lovers meet. Where lovers meet. No. It's not like that at all. Beautiful places, no doubt. But places where rich fishes bring their whores and the bourgeoisie come in their cheap woollens to honeymoon. It's sad what they have done to the land. Still, they're beautiful places if you have no money or are alone. I'm rich and I'm not alone. Christopher and David are singing along with a radio Dylan. I wish they wouldn't. Warda looks at me in the rearview mirror and I know she wishes the same.

~

David and I drink cheap red wine and have sex disguised as love and drink some more cheap red wine. I roll some joints. Ganja and wine— my favourite combination. I want to be more solid and more real but more and more it seems like I'm not here or there or anywhere at all. I see their stories and I hear their words and they are all so unhappy. David is unhappy because he wants and always goes without. Warda is unhappy because, I don't know, she just is. Even young Christopher

with no worries is unhappy because he wants to be a hero but there's nothing to fight for. And all of them constantly telling me they think life has meaning, a purpose to everything, and not believing their own words. They pity me. These fools pity me. I wonder what happened to Joseph. Last time I saw him he was looking fat and old. That's before Warda and I decided Bombay was messing with our souls and moved here. She never talks about him anymore. She was sad about the whole thing. I hated Joseph. He's a creep to beat all creeps in the world. I know that for a fact.

Maybe I'll go to the University tomorrow and sit through some classes for a change. All these people are getting to be too many and too much. Wimsatt Jr. and Brooks might change my life. I'll learn all about the Russian Formalists and the Anglo-American New Critics—listen to the sound of all of them collectively banging their heads against the yellow brick wall. I can't stand it. Everybody in class saying Tolkien is this and that and Gollum is *really* a schizophrenic and the book is *really* about Hitler and Page and Plant *really* sang about Lady Galadriel and not about just any old stairway to heaven. Anything is anything if you think about it long enough. Besides, everything is connected. Networks here and there and everywhere. That's all there is to it. I'm ashamed of myself because I sit and do nothing except complain about people who try. Pointless feminism and pointless post-colonialism. Slaves will continue to talk about their bondage long after they're free. Just another one of those things that is and should never be. I feel like that sometimes. Like it's pointless. Just words on paper. I know better. It makes me angry that I am worth nothing. I have an ego the size of Everest worth nothing. Tell me again, why am I going to the Yoonifartissy tomorrow? Beecause, honeychile, you so bored with dese peeple aroun you, you jus wan see dem diffren faces. Okay. Must be one of those sound and fury days when I signify nothing.

David has fallen asleep, human on my faithless couch. I almost pity him but stop myself just in time.

Guano walks in, proud as only a cat can be. I give him milk and he laps it up and looks at me in disdain. We watch TV in companionable silence. I watch reruns of *Full House* and feel my IQ slump. I like having Guano around. He wants nothing from me and doesn't expect me to make sense of what I'm saying. Guano is the more perfect lover. He shadowboxes with the wall. Who can understand the affairs of cats? He looks at me like he's asking What are you looking at? I look back a look that says Nothing much, not much. I remember reading some bit of criticism that talked about some story with a woman and a cat in it. It said that there's a masturbatory quality to the scene in which she's stroking the cat and talking to her husband. Really! The things people come up with. This must be discontent I'm feeling. Maybe living on the edges and fringes is not enough for all that I want. An antique learned, academic voice comes booming into my conscience: 'Want *both* in the sense of *a desire to possess* and in the sense of *lacking something*.' He was explaining a William Carlos William poem. Or was it Wallace Stevens? Some W name anyway. Escapes me now. But it was fantastic, that line. The poor man is wasted and probably bored out of his brains teaching where he is. Susan tells me he's probably bad in bed. She should know. He's interesting. Almost sexless. That's what makes everyone want to sleep with him, I guess. I wouldn't want to. It would take the shine off his pearls of wisdom. The Professor is the closest I have to an idol. Terrible when idols, like parents, fall off their pedestals and lie face down in the dust. Makes you feel like kicking them in their arse and getting on with it. I have no ruth. Probably the reason why Guano is the only real friend I have. That poem had something to do with delicious peaches in the refrigerator. Or was it apples in the cupboard? Some fleshy fruit anyway. Fruit—forbidden. Refrigerator—domesticity. Food—sex. Apology—hindsight. The smart creep in class with his pompous voice and polysyllables said that the underlying meaning was that a trespass had been committed and forgiveness was being asked (all this apparently very feminist since an anti-feminist poem would entail no apology from a man). Jesus fucking Christ.

All this talk of food. There are oranges in my refrigerator. I like oranges. They're sexy. They smell so innocent and the whole denuding

thing before you feel the juice inside your mouth—very subtle. I grin lecherously to myself in the mirror. I should be in the movies. I like collecting all the pips in my hand and dumping all of them into the ashtray in the end. Makes the finality of an orange gone so real. I'd like to smoke a cigarette now but that would ruin the taste in my mouth. Not yet.

The ancient Greeks should have had television. They would have been so utterly bored and philosophy would never have been born. No series of footnotes to Frère Plato and Frère Aristotle. I'm too self-regarding and it will be my bane. Guano stretches and yawns. I think I'll just sleep. Can't be late tomorrow. The hallowed halls of the University beckon.

Frère Jacques Frère Jacques
Dormez-vous? Dormez-vous?
Sonnez les matines, sonnez les matines
Ding ding dong, ding ding dong.

Natasha, you must stop living in your head like this. You must stop talking to yourself all the time. You must. Or they'll put you in a place where the walls are white and the drugs make you drool. A place where the grass is green and the air is free and they listen courteously to whatever you have to say. They'll takes notes in their little black books. They'll lock you up and tell you it's for your own good when in reality all they want to do is protect the world from your wrath. You must stop, Natasha. You must stop.

This happens sometimes. I tell myself that things are very sane.

~

Haven't seen dawn for ages. I do, today. Bathe and change and make my lonely breakfast. Guano is all yawns and stretches and looks happy for some strange reason. I can hear birds. Birds! Humankind is slowly forgetting the really important things in life. Like the sound of birds. We are turning into a fell race that does not deserve the earth. I don't want to wake David up. He looks too calm and besides, if he wakes up

I won't be able to listen to the birds. Guano gets raw egg and a saucerful of milk. I pat him goodbye and leave a note for David.

Does the earth really renew herself during the night or do we feel that because we do it to ourselves? Why think of such crap in the dewy morn? The jewy morn. I'll walk. Pune is pretty. It's neither old nor young. Bombay, for instance, is old and corrupt. Bangalore is too young. Pune's just right. Of course, I have no idea what I'm saying. I don't ever want to leave this place. Unless I'm going somewhere exotic like Ireland, Istanbul or Spain. I have no pluck. I don't miss it all that much. Nothing's right la-la.

I play cricket with the streetkids. Urchins. Victor Hugo has an f word for them. Forget what it is. I bat and bowl an over each and make them happy. They've seen me around and call me Cigarette. Only it sounds like Seegrett. Most of them sell dope for a living. I know because I buy from them if I'm too desperate, or too lazy to make the trip to Wakad. They like me. I'm the only girl they've seen who scores. Girls don't usually score drugs. The boys do it for them. How feminist of me. I give myself a pat on the back for being so self-sufficient. I give them a 20 and tell them to go have chai. It's useless. They run to get bidis and buy a new rubber ball. They're nice kids.

The Professor passes by on his bike. He pretends not to see me. He's smiling to himself. I've never seen him smile except when he makes some really sarky comment out of the corner of his mouth. Doesn't look half as bad when he smiles. Bad teeth, though. Where's he going this early? Classes don't start for another two hours at least.

I walk again. Johnny Walker. Keep walking. I keep forgetting how it's spelt. I plug my earphones in and switch on the Discman. I love CCR. It's so happy American. Happy American music is all about stars and stripes and rivers and girls breaking promises or keeping them. Sad American music is about war and plastic. Tom Sawyer and Uncle Tom. Last night I asked David if there was some little piece of music that made him insanely happy or horribly sad. No, he said. Then I asked him

if there was some *kind* of music he liked very much—if he was a hard rock kind of person or a country kind or grunge or alternative or pop or anything. He said he listened to all kinds of music because he listened to all kinds of music. What kind of a shitass answer was that? Nothing except life makes him happy or sad. Sometimes I wonder if there isn't a little alien sitting in his head and shifting little gears to make him move and think. God bless the Americans for movies and music.

∾

People from all sorts of strange countries come to the University. Mostly Iranians with lots of money. Eyeranians, as Fokker calls them. They act like Americans. The Americans act like they know all about Kreeshna and Sheeva and leengams and yonees. Yoni. Such a funny word. I'd fall down laughing if somebody called my thing yoni. A Nether Region Named Yoni. Yoniface. Yoni in the Sky with Diamonds. These firangs see me sitting all alone and smoking and think I'm easy. Indian girls don't smoke, see? And if they do, they must be really rich and fast, looking for a gora to lay. Fucking creeps. They all want my yoni. Pauvre yoni.

The Professor passes by with his wife on his bike. She's carrying a duffel bag. Fokker walks in. He's a riot. Wears dark glasses and pretends there's this whole cloak-and-dagger scene going on. He waves a droopy arm at me. I once wrote a story with distinctly lesbian overtones for his Creative Writing session. He's taken to waving languidly at me since then. I wave back equally languidly and hope he can't read my mind. He likes pretending he's famous. He is, I guess. Talks only about himself in the CW classes. Likes the smart creep a lot. Both of them like images that have to do with masturbation and excrement. Yuck. But I love the way his dark glasses hide his eyes and scream out don't look at me but look at me for God's sake please but pretend you're not looking at me for God's sake please. I'm sure he'd wear an overcoat if he could.

It's a nice and breezy October morning. I love October mornings. Partly because it's supposed to be fall and partly because it just sounds

so cool; like the whole nightingale thing. Some words just sound nice and Sunday morning easy—shimmering, glittering, silver, fell, somersault, Stanislavski, Petrucci, kin, gently, clothe, bacchanal and so on ad infinitum. Take the word civil, for example. It does nothing to me. Like plastic furniture it just sits there staring. All function and no art. On the other hand, take the word meandering. Now that's a word. It shows a brook, running water, a traveller, a riff going nowhere, a conversation. I've gone through three cups of chai. Must be wreaking havoc with my system. Whatever's left of it anyway.

~

There are 35 students in this class and only five of them can hold a conversation in English. No use blaming the system because if the system didn't allow for it, it wouldn't happen. This, maybe, is what the system wants. What are they going to do? People who know no English teaching people who know even less. And a few here and there who sometimes know more than the teachers (of art, if nothing else). Very political today. Makes me feel so superclever all because I can spell better than the poor bastard who's teaching me for a pittance. I'm putrid. There's no hope for me or the system. We are all going down.

Break. Finally I smoke zee ceegarette, Sancho Panza.

When I get back, I see Susan. She always misses the first class. I don't miss classes. I miss entire days. I don't do it on purpose. It just so happens that sometimes I forget there's a life to be lived while I'm in my room where no reason walks in. She smells lovely. It reminds me of something I've forgotten and never will remember.
'Hi Susan.'
'Hi Tasha. You look terrible. What have you been doing to yourself?'
She thinks she sounds very sweet when she calls me Tasha. Poo on her sweetness.
'Nothing much. Didn't sleep last night. How's life?'
'Beautiful, as always. Herr Doktor's class now?'
'Of course, sweetheart. Why would you be here otherwise?'

'Of course. His hands are like sandpaper, you know.'

She squeals into laughter. It sounds ghastly. Strange how everybody likes giving the world a peek into their sordid lives. Must make them feel famous if nothing else.

'Yes. Yes. Of course.'

'Of course.'

Santa Maria! This is like some mindless existential play. The knowledge of too much art is detrimental to the appreciation of reality. Another one of the Professor's pearls, though I suspect he's jacked it off from somewhere. Now he walks in and looks around, lord of all he surveys etc.

Susan sleeps. She's just looking for a father figure because she thinks she's supposed to.

~

I'm looking at the clock and concentrating on making the hour hand move backwards. I'm using my powers of telekinesis. It doesn't work so I try the minute hand. That doesn't work either, so I try the second hand, and I think I succeed. I move it back only two seconds but I've done it. Who knows what I may be able to do tomorrow? Hail, Natasha! Shieldmaiden and empress of Time! All hail! Hush, my fellow travellers. Now is not the time to tarry and wanderlust. Now is the time to pick up your swords and FIGHT! Follow me! Follow me!

~

It's so dark and there isn't much of a crowd. Nobody wants to watch Polanski movies. They might want to at FTII but not at Alka Talkies. The usual ads—beware of pickpockets (the pickpocket in the cartoon looks remarkably like Meyrick); chewing of tobacco in the auditorium is strictly prohibited, anybody found doing so will be liable to pay a fine of Rs 100 or face upto one month imprisonment; please switch off your pagers and mobiles; by order of management. Nobody pays any attention. Rhett and I take our shoes off and put our feet up on the

seats in front of us. They show a depressing documentary about the earthquake in Gujarat. Lots of starving kids and handicapped people. Rhett says it's to make the middle-class feel guilty. An old man sits up ahead in the distance. Rhett tells me they put him in here when they built the auditorium in 1970 and forgot to take him out again. I tell him not to be an ass. The Nirma ad comes on. Rhett and I sing along. *Nirma, Nirma, Nirma detergent tikiya iski jhaaaaag ne jadoo kar diya*. It's been on screen since the dinosaurs walked the earth. India will have lost something the day they stop airing it—*dhero kapde dhoye aur zyaada chale*. Rhett and I discuss other jingles we've grown up with so we can ignore the depressing documentary. *Bhool na jana, ECE bulb laana—tandurasti ki raksha karta hai Lifebuoy, Lifebuoy hai jahan tandurasti hain wahan—Vicco tur-mer-ic, nahin cos-me-tic, Vicco tur-mer-ic ayur-vedic cream*.

It's over. Finis.

Rhett is laughing and talking of something I couldn't care less about. I hate coming out into real life. The dirt and grime and lack of music break everything.

~

I'm sick of doing nothing. I'm sick of being this sensation-seeking personality. I don't hate anyone or love anyone. I have nothing. I've never been through war or met an alien. Hollywood can make anyone feel wasted. I'd like to cry for real.

~

I don't want to attend classes or feel like I'm worth anything today. I feel like I've gone through a lobotomy and the doctor goes out mournfully and tells my mother, We are sorry, we tried our best but the operation was a failure, and my mother shrieks and falls down.

I buy aluminium foil and bidis on the way back.

It's so important that the music be right. Complicated music is perfect for ganja. Chemicals need loud, repetitive, mindless noise. Charas needs alien music. Coke and heroin need silence while the trip lasts. After the trip I like going out and looking at people. Chasing brown is different. I don't do it to get stoned but just to enjoy the whole affair while it lasts. I'm addicted to the silver foil and matchsticks and watching the stuff heat up and run down. What should it be today? Wish I had a 12-CD changer.

I arrange everything for optimum comfort. The armchair near the window. The table in front of the armchair. Foil cut into strips just the right size. Not too narrow, not too wide, not so long it bends and not so short that a hard chase becomes impossible. Bottle of water so I don't have to get up and break my trip. Remote control. Matchsticks in a little pile. Zippo just in case. Personally, I don't like Zippos but they're useful when your arms stop being your own. The foil pipette for chasing the dragons.

The best part is the chase itself. It's better if there's someone to do the donkey-work but like everything else I have to do it for myself. The tiny heap of brown powder that swiftly turns into a stream and runs down the foil and I have to get the little wisps of smoke before they escape and then turn the foil around with expertise acquired from years of handling and make the stream run down the other way.

I'm sitting with a lot of people and laughing prettily. My arms shine like burnished gold. Karan, maybe it's Rohan, comes and puts his hand over my eyes and I don't know it's him. Then I turn back and am so surprised. He hugs me and lifts me off the ground. All these ridiculous things happen in slow motion.

I pretend I'm tough enough to take any amount of pounding. But really, I'm not. Nobody believes me. There's a tree outside the window and a used condom hanging on one of the branches. There's too much rubber and used plastic in the world. Someday, we'll all drown under used condoms. There aren't too many people down on the street. I must stop thinking about him. He used to whisper J'adore...j'adore.

Passage to Bangkok. I've never seen another country. I want to. I don't think I ever will. There are some things I'm glad about. I'm glad I never had to fight for suffrage. I'm glad I wasn't Judith Shakespeare. I'm glad my body is whole and still in working condition. I'm glad I have loved and been loved in return. There. All my blessings. I'm glad I'm glad I'm glad. I want to be a hero. Sometimes I'm scared there might be a man inside me because I wish for war. Sometimes. I want to die and give all to a thing I don't expect to understand. I have nothing. I am only ashamed that my heart aches so. An aching heart is such a ridiculous notion. It's supposed to be okay to feel like this. I don't feel okay. I feel like shit.

I look down and see two people hugging near a streetlamp. Streetlamp. Why am I thinking about streetlamps? I'm not thinking about streetlamps. I'm thinking about Rohan's voice. Maybe it's Karan's. Who am I to blow against anything?

∽

How did I get here? I don't remember walking to the bed. Guano is staring at me. 'I'm changing, Guano.'

Now I'm talking to my cat. When I find my peace of mind I'll share it with someone who deserves it. They want me to be them. To think like them. To stop being a curiosity. To not blink. To not scatter like light. I have to stop blaming Them. The big, crawling, unseen, all-screaming, clockwork Them.

I have a Vuitton handbag that cost my mother the earth when she bought it about a decade back. That's the time when childhood clouded my perception and I thought I was happy. I have a little opulence in the form of my mother's old handbag. It has aged gracefully, like her. Sometimes I just hold it and smell it. All the perfumed handkerchiefs that my mother carried around have left behind their ghosts. She was so beautiful. So bloody beautiful and looked so young in her wedding photos, staring with large, startled

eyes at the world. She had an orchid stuck in her hair. Sometimes I feel like crying when I think that I'll never look like that. Maybe that's what Karan meant when he said I wasn't girl enough.

We were listening to Highway Star and I asked Karan who's on lead. I knew but it had completely flown out of my head with winged hooves. (Hooves??) He turned to me in mock astonishment: 'You don't know? Baby, your ignorance appals me. Now listen very carefully and remember this forever. Ritchie Blackmore on lead. He's the important guy and the most talented. Tommy Bolin used to sing lead but he died of an o.d. Then David Coverdale came in but he fucked up majorly. They disbanded and Ritchie Blackmore formed Rainbow. Temple of the King? Yes. You're not a complete ass, you know. Very important— Ronny James Dio did the vocals for Rainbow. David Coverdale formed Whitesnake but they mostly did screwy, soppy stuff and nobody liked them.' There. I remembered the whole damn thing. Forever. What will happen if I lose my memory? Remembering stuff is all I'm good at.

Maybe I'm this obsessive person who can't stop thinking about the same things. It's possible. Now that I have this interesting piece of information about myself what do I do with it? Can't ask my head to stop thinking. We have a curious case here, Hastings. Whaddya think? Eh bien etc. There is a weird feeling in my stomach. I feel like there's a rock stuck inside of me. Not exactly fear but very much like it.

It might be blue
It might be fun
So go to the beaches
And suntan your bum
Poor Joyce. Must be turning in his grave by now. I've never liked his face much with the one eye that looks bigger than the other because of the glasses. He looks so cold and unforgiving. Not like Larkin. Now Larkin looks like he'd forgive you if you were late returning books to the library. Waive the fine etc.

～

I should be working but I'm thinking of poetry. Most of the time I'm just surfing and downloading stuff and burning CDs. I'm supposed to be working very hard towards my deadline next week. The manager is a woman who looks like she walked out of a soap opera. I'm chuckling. I like that word. Chuckling. Chuckling duckling no luckling.

I'm going back to designing for the family business. There's a lot to say for when your grandfather's the boss and loves the hell out of you. Screw independence. This place sucks even though I got to come here only once a week. I don't like the manager woman much. She's too plasticky. Too unreal. I'm pretty sure this is not the non-profit organization they say it is. For one, non-profit organizations wouldn't have cafeterias with canned music playing and dessert for all the employees everyday. I have a name for her. HMS Marooned. That's my secret name for her. She's not a pear. She's an avocado. She's got tiny shoulders and billowing hips. That's the only word for it. Billowing. Looks like they're all filled up with air fit to burst. Sails on a ship. I shouldn't be thinking these thoughts. God will punish me with a lightning rod of cellulite aimed directly at my arse because I have sinned through my own fault in my thoughts. I feel faintly ridiculous and try to smother a laugh but can't. The guy in the next cubicle peers over the partition. I point stupidly at the computer screen and say: 'My brother…he sent me a joke.' And in my words and in what I have done and in what I have failed to do. All the angels and saints and to you my brothers and sisters to pray for me to the Lord our God. Amen. God will take this job away and a Kelson will perish trying to pay electricity bills. Of course not.

This place is filled with beady-eyed people and ochre & grey Formica-topped tables. The woman in the cubicle next to mine is horribly ugly, pauvre femme. Rhett has this theory that harsh, ugly women reach menopause faster then the other kind. Insensitive pig.

~

I stay in bed and read till my eyeballs start aching. I wonder if it's technically possible for my eyeballs to ache. I don't like reading spy

stories. They're always set in places where it's snowing and where I am, even November afternoons make you sweat. November tapta.

There's a man who wears polyester shirts at the office. He's got them in all sorts of ridiculous prints. He's fractured the ring finger of his left hand. I think his wife must have bitten him. The top of his head has a sparse vegetation of moss and lichen. There's a picture of Lakshmi on his table. He sweats too much. Prays to the picture before starting work. In the mornings there's always a red tilak high on his very large forehead. It disappears by the end of the day. Probably flows away with the sweat or something. I know his kind. They go home and kick the dog to get back at the boss. They wear Lux chaddi baniyans and eat no meat or anything that grows underground. In the morning they wake up very early and bathe in cold water. They sit in their pooja rooms and ring the bells loudly to scare the demons away and all the time they worry worry worry about bills and kids and dwindling bank balances. There's also a Czech girl called Jana. She's big and white and smells nice till she opens her mouth. Czechoslovakian halitosis. Yech.

Somebody once told me that Malabaris have strange names because their parents take the first syllables of each other's names to invent a new one. If the mom's called Shilpa, for example, and the dad's called Joseph, they just take Shi and Jo and put it together to make Shijo. Well, as good an explanation as any.

I'm feeling hot and sweaty and my spy is in Helsinki putting laxatives in somebody's coffee. He's just met a girl. Might get interesting. It usually gets interesting after the advent of the girl.

I walk over and look out of the window. There's a man in a blue tracksuit now standing near the streetlamp. Why on earth is he wearing a tracksuit this time of the day?
I'm tired. I think I'll just feel like dying for some time.

~

Good morning sunshine. Happy fucking birthday. Nobody remembers. Nobody cares. That's not true, though. I only wish it. In reality I'm plagued by phone calls from all over the world from people who think this is a really important day for me and I want them to share the infinite joy I feel because I'm older and inching closer to maggots. Jewish or not, I'm going to put in my will that I'd like to be cremated. Guano is nowhere to be seen. There are strange Hindi songs running through my head. They have words like lambi judaai in them and a piece of music that has something to do with snakes. I had a dream where there were lots of people helping me hide because I was being chased by something. They hid me in a movie theatre that had red curtains and all the men in the audience were gay. They weren't doing anything but I just remember that in the dream I was aware that they were all gay. Weird.

A pigeon flies in through the window and bangs into the wall behind me. Is this an omen? It flies and squawks and bangs into everything. I switch off the fan so I don't have a homicide on my conscience. It manages to find the window again and flies out. Must have been blind. Not long for this world. Bird of prey, bird of prey flaaaaaaayin haaaaigh flaaaaaaayin haaaaigh. I feel like Jim Morrison today. I can't do anything about it. Nobody's going to give a rat's arse if I kill myself or disappear. My parents might cry and stuff but really, who's going to bother remembering after a few months?

It's going to continue like this and then suddenly stop forever. I listen to Shacking Up to Chopin and sit in my armchair with a cigarette, dreaming pipedreams. There's no movement in the air and the smoke rings I blow gently flutter out into the world like ashy butterflies. Poetic today, aren't we? No sarcasm just for today. I'll be calm and happy. Shantih shantih shantih. I intercom the watchman downstairs and ask him to get me a pack of Davidoffs. It's a special day. If I insist on killing myself with nicotine, might as well go sumptuous into the good night. Just for today. Can't afford it everyday, of course. I smoke Flakes everyday.

The Davidoffs appear like magic and I say thank you to Bahadur. I don't know what his real name is. I call all watchmen Bahadur. The pack looks so rich and sexy deep purple. Smoking Davidoffs is like drinking Chivas Regal. Your throat sighs and thinks of mellow fires and autumn leaves. It's terrific to be rich. I couldn't work my arse off for anything on earth.

I've never been alone in a pub in my whole life. I think I'll do that tonight. I won't go to Artemis. I know everybody there. They'll try to make me feel okay about being alone. I'll go to Fat of the Land. I don't know why it's called that and I've never been there. Tonight is as good a time as any. Eastward ho!

I'm tired of all the sunlight, the music, the smoke. There's a tub of chocolate-chip icecream in the freezer. I lie back on bed eating icecream, crunching on the chocolate-chippy part, watching TSN ads. They're selling exercise machines, tablets to reduce fat, cyclone drinks to make people lose weight in 24 hours (guaranteed!), creams to make breasts bigger (a really ugly hand is shown massaging cream on even uglier breasts). All these lotions and drinks and creams seem to have a secret herb discovered in the Amazon as the main ingredient. A vision of white-coated quacks combing the Amazon jungle for weird-looking plants comes into my head. They're being eaten alive by mosquitoes and distributing Bibles to the natives. They give firewater in return for being taught the alphabet and corrupt the shamans. I feel massively stupid and asinine thinking such things after watching stuff on TV.

There's a book lying open on my bed. I don't know when I started reading it. *Case Studies of Workers in the Informal Sector.* Mariambibi says her husband left her many, many years ago. Gilbert says, Today I'm a happy man, I'm thinking of marriage. They're so sad. Almost as sad as I am. I, by far, am sadder than they. They have no education but I do. In terms of pure emotion, I am sadder than they because I know more than they do. It's sad.

There's some movie playing that shows this woman in a pointy bra. I have an aversion to anything pointy. During the 80s most Bollywood heroines wore pointy bras. Vyjayantimala, Sharmila, Sridevi. Maybe it was the 70s and not the 80s. Whatever. How am I supposed to know? I call it the Julieboobs Syndrome because there was an explicit boob scene in *Julie*. Julie stands near a window and the camera shows the milk running from her breasts making streaks down the front of her blouse. How did she ever go through that scene without laughing? Immoral or not, I wouldn't have stood for such bad art. Now the Mandakini waterfall scene and the one in *Mera Naam Joker*—that's good art. Very nicely done. My obsession for today is Boob Scenes in Indian Cinema. Maybe I should write a book about it. How about pornography? The Malabaris came out with pornography first. *Her Nights*, then Silk Smitha, Shakila. All indelibly stamped in my memory. Malabaris are obsessed with perverted sex more than other kinds of Indians. They masturbate and fornicate and copulate and remain horny through life. Must be the weather. The wind in their privates because of the lungis. I've noticed that most Malabari men have a face that looks like they feel guilty after they masturbate. In fact, I'm sure it's the weather.

Goans look like they're normal about sex, Bongs are much like Malabaris except they feel guilty in Bengali, Gujaratis look like they don't do it much, Pune-Mumbaikars look like they love it, Manipuris look mysterious about everything. Certain Thoughts About the Sexual Habits of People Belonging to Various Regions of India. The best sex I've had was with a Parsi. Parsimonius sex. Heehee. I must cure myself of this habit of grinning lecherously to myself. Anyone watching me would think I'm the kind who'd plunder the town and rape the women. I've forgotten his name but he was nice and gentle and kept asking me if he was very heavy for me. Also, he had a great schlong, which, if I remember correctly, surprised me at the time since the bawas aren't known for having great schlongs. He had prodigious talent. I wish I could remember his name. He worked in a Levi's store and measured me for jeans. That's how I met him. He told me I have a very nice waist and I replied back in the same vein and told him he

had a pleasing backside. He laughed and was quite charmed by my sarcasm and wry smile and the next thing I know we were at his place ripping each other's clothes off. We had strawberries cold from the refrigerator and listened to Woody Guthrie. I'd love to have an affair like that again. A strawberries, Parsi and Woody Guthrie in bed affair. Hormuz. His name was Hormuz. I remember telling him about my schoolteacher who told the class that porpoise was pronounced as porpiss and tortoise as tortiss. I still say porpoys and tortoys when caught off guard. I remember because there was strange beautiful music all around us. I wonder if he's still around somewhere. He must be, since energy is neither created nor destroyed.

I might be a nymphomaniac. Sex and food is all I ever think about. Mostly, I'm clinically detached about it. I contemplate if that makes me less of a nymphomaniac.

I look strange. A paradox. An anachronism. The lipstick is au naturale and the perfume is lightning. Gucci Envy. I got it two months back when I got paid for designing bracelets for an old fart. She was such a fucking pain. Kept telling me she didn't want platinum, no resale value see? No rubies, use garnets. Cheap as shit, she was. Sad when the rich begin to behave in that abominable manner. Could've willingly throttled her. I don't like high heels. Can't walk in them if I'm drunk. I still have an hour. It's 9 in the night and I don't know where the day went. I didn't even do drugs. It's not fair. I intercom Bahadur again and tell him to call me a rickshaw in some time.

I take my Discman and Weather Report just in case.

∼

'Koregaon,' I tell the rickshawala. There was this rickshaw song with Asrani in it. Can't for my life remember the words.

Traffic jam. There's a car next to me. The windows are rolled up halfway. There's a successful-looking man at the wheel and a cheerful-

looking lady with a kid on her lap. Must be the wife. The kid holds a McDonalds balloon in his hand. In the back there's an old lady playing bo-peep with a baby. She looks like Phil Donahue. The baby looks like Chucky from *Child's Play*. Shiver me timbers. The rickshawala is humming to himself. Something from *Rudaali*, I think. Bhupen Hazarika with his cracked hooming and humming. It sounds all deserty and sandy and waiting for tapta. Or maybe it's just the movie that makes me think of the desert.

The lights turn green. I find myself thinking of Sara for some reason. She hated Hindi music and movies and called herself an Anglo-Indian though she wasn't one. I feel sorry for her. She had nice creamy thighs. That's all I'll ever remember about her.

Here I am. Fat of the Land. I feel nervous. What does one do alone in a pub? One drinks, Natasha. One drinks oneself to death. I walk in. Sort of like Ghetto's in Bombay. Not too bad. Not too new. Passable music. Bartenders look okay. They're eyeing me curiously, not suspiciously. I walk to the bar and hoist myself up on the barstool and keep my Vuitton next to the ashtray. It makes me feel confident. What is the difference between a pub, a bar and a club? I don't know. The bartender is dressed in black and white like all of his clan. He is small and neat. Why are small men always so neat? He has a huge handlebar moustache and reminds me of one of the Mario brothers. I forget which one. Luigi, maybe. He asks, 'What would you like to have, madam?' I should start slow and stick to one drink. 'Bloody Mary,' I say. 'Very good, madam,' he says, as if I were some especially deserving student in school. I watch him mix my drinks. I like the man. Loves his job. Nothing flashy but entertaining all the same. If he doesn't stop calling me madam I'm going to break out in a rash.

The rickshaw took a shortcut through a slummy area. There was a kid squatting by the road, his cute little ass hanging out, delicately poised over runny shit. Reminded me of chefs on TV putting whipped cream on cake, it did. I don't want to think about it. Not when I'm drinking but it walks into my head. My country, the land of the free, where

101

anybody at all can shit anywhere at all. I think it's quite marvellous, this utter lack of, this utter lack of. I don't know what it is an utter lack of.

He has such nice manners and I wonder where he's from, I think he reads my mind because he tells me he's called Jamie and he's from Mauritius. Curiouser and curiouser. Am I going to sit here and talk to this Jamie from Mauritius till I leave? Maybe I am. It looks beautiful. Like a lady. Drinking it would destroy its formal beauty so I just stare at it for some time. When I was a kid, my mother took me to the zoo and showed me a zebra. It glistened in the sun and the zookeeper let me touch it. Like heaven. This feels the same. Only different.

I tell him, 'There's a certain kind of people who put all their favourite songs on one tape or CD and call it ASSORTED or PARTY HITS or ALL TIME FAVOURITES. I hate them, Jamie.' He gives me an I-understand-completely look.

~

I meet this guy called Khaled and we go his place. I don't know why I'm always with someone or the other. I'm not scared of being alone. Still. Must be some reason why I keep looking for someone to sleep with. Strange thing is that I fall in love with most of them. Fall out pretty quickly too. The knocker is a brass gargoyle. Quite hideous. Why would anyone want to have a brass gargoyle on the door? The paint is old and almost peeling but not quite. That's a good sign. I hate the smell of fresh paint. Khaled's explaining to me that his parents and brother stay in Canada and he's here for a year because he needed a long vacation. I stand and wait for him to unlock the door and wonder if maybe he's been circumcised as a baby.

We walk into the dark and he goes ahead to switch the lights on. I feel like I've walked into Miss Marple's room. This is exactly how I've always imagined it. I sink gratefully into a low comfortable couch. There are no ugly fluorescent tubelights. Everything's warm and

golden. I look around and listen to the sounds coming from the kitchen. The refrigerator door opens. I hope he's not bringing more alcohol. I'll throw up if I drink any more. There are two armchairs right and left of the couch. The one in my room was bought second-hand from a shipbreaking yard. These look made to order. They have some kind of pattern on them that reminds me vaguely of the Incas. Everything is in wood and heavy cloth and reeks of home. I can't see any signs of women around. Looks like the things have been put into use only recently. I give myself up to Bloody Mary stupor and close my eyes. The kitchen sounds come in more clearly. Gas being turned on. Loud click. Scrape of saucepan against burner. Jar lid being unscrewed. Spoon against glass. Cups being taken off hooks. Sizzling sound of milk coming to a rising boil. Spoon against glass again. Gas being turned off. Saucepan into the sink. Water running. Spoon stirring in cups. One. Two. He should be out now and he is even as I finish the thought. He comes out with two steaming mugs of coffee and places them on the table in front of me. He flops down on the couch and throws off his shoes and invites me to do the same. I bend down to unshackle my feet and before I can say anything he's down on his knees with my feet in his hands saying, 'Allow me.' I allow him. I'd allow murder right now.

'So, Natasha,' Khaled says.

'So, Khaled,' I say.

'Why were you sitting all alone?' he asks.

'I couldn't think of anybody I wanted to be with,' I say.

'Do you want to be with me right now?'

Sweet Jesus. Who in the name of fuck does he think he is?

'Want in the sense of lacking something or want in the sense of a desire to possess?' I ask in my best Jeeves voice.

He turns to me and folds a leg under him and rests his elbow on the backrest of the couch. I do the same and cradle my mug in my palm.

'What do you do?'

'Like what are you talking about?'

'Like what do you do for a living?'

'Design jewellery.'

I'm sick of telling people that I DESIGN JEWELLERY like it's

something so important.

'How very interesting. Most people I meet seem to studying for an MBA or work in call-centres.'

'I hate call-centres.'

'I hate them too,' he says so solemnly I have to laugh.

The coffee tastes lovely. It's got a hint of mint in it.

'Is this Jamaican?' I ask.

'Yes.'

He's done with his coffee and I'm done with mine. He gets up and switches off all other lights after putting on the night lamp. He takes my hand and I take my bag and follow him to a flight of stairs. It's too dark to be sure but I think the steps are all blue. I put a hand out to steady myself and feel glass cold under my palm. The bloody steps have no handrails on the other side. My feet feel the cold cement. Is it cement? I don't know. Definitely not tiles. We come to a room and Khaled puts on the light. It's so bloody huge I almost gasp. Then I control myself and tell my pretty little face not to act like Babe, pig in the city. The walls are the palest blue silk and there are no paintings or anything. The room has no pictures—not a single thing on the walls. There are lots of big windows without bars and the night breeze brings in with it many tangible smells of wet soil and flowers. There's a big bed and a home theatre in front of it. I walk a little unsteadily to the bed and sit down on it. I now see that there's a table to the left of where I was standing. It's got strange shiny objects on it. Khaled has disappeared. I can hear the sound he makes when he lifts the toilet seat and pees. I walk on bare feet to the table and look at the things on it. I don't touch anything. They look very delicate. I don't know. Could be a nuclear bomb.

'I do tattoos,' Khaled says from behind me.

'Figured as much,' I tell him.

'Do you want to use the bathroom? In the sense of lacking something.'

'Ha ha,' I say and go to the loo. I take my own sweet time and snort a line of coke and pee in bliss. I come out to find him fiddling with the music. He asks me if there's anything particular I'd like to listen to. I say no. I want to see what he plays. He plays Steve Vai and passes.

'I'd like very much to make love to you. May I?' he says.

'My pleasure,' I say.

'It will be,' he says.

Conceited little dope.

I feel like an idiot. Wallowing in my glorious youth. I feel like we're two good-natured bisons having a romp and almost snort in my valiant effort to not laugh.

~

We leave for Goa the next morning. I need a vacation anyway and it's okay if this Khaled wants to tag along. We take the train and he reads something on the history of pornography and quotes loudly from it now and then at brief intervals. I meet this Japanese girl with a name I can't pronounce so I just call her Haiku. I can't understand anything she says but she's quite sweet and so hairless I'm awestruck. I keep staring at her bare arms.

We get to the hotel and it's all very restless and awkward on account of the fact that Khaled and I barely know each other so we change and go out to explore the countryside. Khaled has never been to Goa. What an asshole. We come to a shack that seems empty. I didn't think any place that served alcohol in Goa would be empty this time of the year. There are rickety tables and chairs and a guy at one of them with a blue guitar propped up next to his leg. I tell Khaled it's a sign and we stop. We order feni. It's not too stinky when it comes. Usually feni smells like something the cat threw up. It's good if you want to get drunk real quick.

The man with the blue guitar strums for some time. It's like I'm watching a poem come alive. Then he sings Rhinestone Cowboy in a voice so cracked it makes me think maybe I made a mistake. Khaled looks at me and enjoys my discomfort. The man and his blue guitar come to our table and he asks Khaled if he can join us. Khaled tells him to go ahead and buys him a drink. Blue Guitar gulps it and says

he's a tourist guide and hates his job. I ask him what is it that he has to do.

'Fool those fuckers. Make sure everything sells at double price. I get commissions from the bars and hotel owners if I get them customers. Buggers won't let me live.'

Sounds like swindling. I already love the guy. He says he's called Raj and reminds me of Fokker for some strange reason. Same height, same beard, same shifty eyes.

'What are you doing here?' Khaled asks him.

I think maybe he's on the lookout for some firangs to bugger.

'I'm waiting for Mario,' he says.

'Who's Mario?' I ask.

'Mario is my brother. He owns Mapusa.'

Okay. A brother who owns Mapusa. I believe that.

We're halfway through our second round when a fuchsia Zen pulls up and honks loudly. Weird color for a car. Raj jumps up and goes to it. He puts his head in at the window and promptly gets slapped on the cheek by a hand that has lots of gold rings on it. It's too dark to see anything else and he and the driver have a long conversation. I wish I could hear what they're saying. Khaled tells me I spilt feni on my jeans and grins at me when I appear not to care. Then Raj steps aside and the door opens and out comes the most peculiar-looking man I have ever set my eyes on. He must be about as tall as I am (that's not too tall) and has the swarthy complexion of an Arab. I don't know what that means but I'm sure the word Moorish would have described it too. He looks nothing like Raj. He's wearing a white linen shirt that shows off most of his gleaming, oiled chest and dark blue jeans that are so tight I can see he prefers arranging his balls to the left. He's got a well-trimmed beard and moustache. His facial hair is a work of art. He's wearing a gold chain that's thick as a rope and has a solid gold medallion the size of my palm hanging on it. I'm half-afraid he'll chew on a splinter of wood and give water to dying Indians. Raj looks like he'll fall on his knees and crawl backwards saying yes sahib no sahib any moment now. He walks towards us like he owns the world and knows it. He cracks the knuckles of his ringed fingers. He comes

closer and I see that he's wearing cowboy boots with heels. He sits without waiting to be asked, a little on the edge of the seat, legs apart like he's got no time for this. I kick Khaled under the table when I see spurs. Spurs! By the look on Khaled's face I guess he's seen it too.

'I'm Mario,' he says like we know all about him.
'Raj has told us all about you,' I say like I'm being introduced to my mother's friends at an English tea party though I haven't the faintest idea what an English tea party's like. Khaled snorts. Mario looks at me fondly and says, 'Raj says you are both alone and don't know where to go.' I look at Raj who's standing behind Mario and nodding desperately. I say, 'Ye-es,' though it's not true and am very doubtful about where all this is leading. Khaled is amused and of no help. Mario says, 'Come with me.' His face has you-don't-have-a-choice written all over it. I mumble something while Khaled pays the bill and pulls me along to Mario's Barbie doll car. Raj follows and looks so gratefully at me I'm beginning to wonder if he's not, maybe, a little touched in his head.

Mario holds the door open for me and I get in, followed by Khaled. He gets in behind the wheel and Raj next to him. He puts on the music (Meatloaf—I'm offended) and holds up a bottle of Bacardi and Old Monk and asks me what I what. 'Bacardi,' I say. He passes the bottle to me and takes a swig off Old Monk and passes it to Raj who passes it to Khaled while I'm trying to open the bottle in my hand. Khaled takes the bottle from me and tells me to have some Old Monk. It's been mixed with Pepsi. Yuck. Tastes like shit. I'm sure to throw up if I drink too much of it. I pass it back to Raj.

Mario is performing the amazing feat of rolling a joint and driving at the same time. I watch him spellbound. He toasts the stuff, pulls out a Rizla, mixes tobacco, lets go of the steering wheel while he deftly rolls it. He puts his eyes on the road and his hands back upon the wheel and gives the joint a final lick. All this going ninety. Damn. I'm ready to follow Mario to the ends of the earth. Poor Khaled. He's directly behind Mario. He's missed it.

'Where are we going, Mario?' I lean forward between the seats and ask. He gives me the joint so I can shoot it. I am deeply honoured.

'Call me Ganesh. My friends call me Ganesh.'

'Why do your friends call you Ganesh, Mario?' Khaled asks.

'That's my name. Only these bloody firangs call me Mario. I tell them my parents were Spanish and they believe it.'

'Do you speak Spanish?' Khaled asks.

'No. My parents are not Spanish, understand? I'm an Indian. Firangs are stupid. They believe anything,' he says.

'Why do you want them to think you're Spanish?' I ask.

'Easier for them to trust people with a foreign name,' Mario says and slaps Raj on the thigh, 'They'd suspect this Raj here but they won't suspect Natasha or Mario. Firangs are stupid,' he says again.

I think this is some *really* twisted logic and smoke the joint and pass it to Khaled who passes it to Raj. It smells like Afghan maal.

'Is it Afghan maal?' I ask Mario.

He looks at me in the rearview mirror and grins to show the whitest, pearliest teeth I've seen and says, 'You know.'

'Who doesn't,' I tell him.

Mario shifts gears and drives the car at breakneck speed. I see the needle pass 120. We pass over a bridge and I see the reflection of neon on water whizz by. Raj is very quiet and the guitar is resting on the floor with its neck between his legs. He can't play it to save his life. Why does he carry it around?

'Where are we going?' Khaled asks.

'Cidade,' Mario says, takes another swig and wipes his mouth with the back of his hand.

I lay my head back on Khaled's shoulder. He puts an arm around me and we talk softly. I smoke a cigarette and feel slightly buzzed. Old Monk is over so the Bacardi keeps getting passed around.

'Do you think he'll kill us?' I ask Khaled.

'No. He's really sweet,' Khaled says.

'I think he's mad.'

'He's not mad. But the other one is.'

I look at Raj who's trying to tune his guitar.

'Is Mario a Spanish name?' I ask.

'Must be,' he says.

We drive into the gates of Cidade and the car goes up a twisting path lined with shrubs and soft faery lights. I roll the windows down and listen to the sound of music come in closer. I'm a little freaked out. Maybe I look strange. There will be lots of people around. They might crowd around me to laugh. God, how I hate crowds. We get out of the car and Raj gets out with his guitar.

'Put it back,' Mario says and boxes him on the ear. Raj laughs and puts it back upright on his seat. Khaled glances at me. Mario hooks his fingers into the waist of his jeans and walks in an exaggerated cartoon cowboy manner. Somehow, it suits him. I tell Raj it's okay. Raj shakes his head mournfully.

Everybody is lined up to get in. Mario does his crazy cowboy thing and walks with spurs et al to the bouncer at the entrance who waves him in and puts an arm out to stop the rest of us. Mario turns around, glowers at the poor chap and says, 'They're with me,' in a very menacing sort of way. The chap takes his arm off like he's been stung and seems to shrink where he's standing. We walk into the middle of an all-dancing all-singing golden crowd. There might be some truth in the Mapusa story. Khaled looks at me and raises an eyebrow. I raise mine in answer. Telepathic conversation done, we look around while we follow Mario, who's winding his way through the crowd. Lots of firangs and very rich-looking natives. We go to the bar. Everybody seems to know Mario. They get him drinks and seats and look at us with new respect when they learn we're with him and Raj. The four of us sit around a low table and somebody (doesn't look like a waiter— higher up in the pecking order) brings tequilas, lemon quarters and salt. Also, a bottle of champagne smothered in ice. Mario is very cheery and backslappy, doing the whole Catholic Uncle routine. We throw back our heads for the tequila and lick salt off our hands and squeeze the lemon into our mouths. Grrrrr. I feel like an animal. As

soon as it hits my head I know it's not just tequila I've taken in. The voices fade out into the distance and all I'm aware of for some time is my hand floating away from my body.

'Aye yam fraam Rrrasheea,' somebody's shouting to somebody else.

Mario is talking very seriously to Khaled.

'A nice girl,' he says.

Are they talking about me? No one's called me a nice girl ever. Why are they talking about me like I'm not there?

'Yes,' Khaled says.

'I can get as many women as I want,' Mario says. He sounds tired when he says it.

'Yes,' Khaled says.

Is he stoned? Are we all stoned?

'So many women will sleep with me for nothing.'

'Okay.'

'Do you love her?'

'I don't know.'

'You love her.'

'Okay.'

'Does she love you?'

'I don't know.'

'She loves you.'

'Okay.'

This is insane. This is fucking insane. I'd normally protest but my tongue, along with my arm, has floated away into some part of the universe that I don't inhabit.

Mario pops open champagne and pours it out into four flutes. Flutes? Fluted glasses, I think I mean. He hands me one and Khaled and Raj take one each.

'This Raj is an idiot,' Mario says.

'I am an idiot,' Raj smiles and repeats like he means every word.

'Let's dance,' Mario says suddenly and drinks his champagne in one long drag. He gets up and comes and stands behind me. Puts a hand on my shoulder and looks at Khaled who has gone red in the face

trying not to laugh. I follow Mario and hope that the spurs don't hurt my feet or something.

Mario is surprisingly good. He holds me close enough so I can smell Eternity on his cheek. His hair looks very black and looks like they've been trained in the army. I feel a little uneasy.
'Be free. Be free. Come on lady, be free. I'm not going to eat you up. Many girls will sleep with me for nothing.'
Insolent little prick.
'I heard.'
'Is that your boyfriend?'
'I guess.'
'You can dance with him later.'
'Whatever.'
We salsa and at the end of the dance he gives my bottom a friendly little pat. I glare at him but he smiles so sweetly I have to forgive him.

We go back to where Khaled and Raj are waiting. We drink some more and Khaled drags me away from there. The sand gets between my toes. It's very irritating.
'This is weird,' he says.
I like Ted Lapidus more than Eternity.
'Who cares? I'm having fun.'
'So am I.'
I look over his shoulder and see a really pale, pretty girl talking to Mario. She kisses him and he waves her away. Must be one of those girls who'll sleep with him for free. I turn so Khaled can see her too.
'Can you see her?'
'God, she's good-looking.'
We're curious but we take our own time to get back to Mario. She's gone by then and Mario slits his eyes at me.
'Imported from Burma,' he says by way of explanation. Mario justifying the ways of Mario to men. Jeez. He looks evil.

Presently, a tall cadaver walks by and stops when he sees Mario.
'Ganesha!' he exclaims quietly.

Mario stands up and they hug like twins separated at the Kumbh doing the bhaiya-bhaiya stunt. A chair appears and the cadaver sits down gingerly. Mario pours out champagne for him and calls for more.

'Meet my dear friend Xavier,' he says and slaps Xavier on the back. Xavier looks like he'll decompose swiftly if he moves too much. He turns to us and nods acknowledgement.

Mario turns to Xavier, points at us with his cigar and says, 'These are my good friends, Natasha and Khaled.'

I'm wondering how dear exactly a friend is Xavier to Mario.

'Xavier got out of jail yesterday. Five years my friend was in jail. But Ganesha made sure he was com-for-table. Looked after him like a brother. Didn't he, Xavier?'

Xavier looks like he's trying to figure out a way to unscrew the bolts of the coffin he's trapped in.

'Yes,' he says after a while.

My very first real life criminal. I'm so bloody kicked.

'All because of Our Lady of Perpetual Succour,' Mario says.

'All because of Our Lady,' Xavier agrees.

What the hell are they talking about? They lapse into something that sounds like Konkani, I'm not too sure. I look around. Khaled and I excuse ourselves and walk around. We come to a railing and stand there to smoke and look out at the sea. We comment on the lowlifes we can see and talk like snobs about how everybody dressed. We get bored and go back to Mario. The corpse called Xavier has disappeared.

'Where did you go?' he asks.

'Just looking around,' I say.

'Have you seen Raj?'

'No.'

He turns to Khaled. 'Have you?'

'No,' Khaled says.

Somebody then comes and whispers something in Mario's ear. He gets up and asks us to go with him. The three of us come to a group of people who are looking down at something on the ground. It's Raj

lying sprawled with blood streaming from his skull and a bottle lying next to his head. Mario goes down on his knee and asks, 'Who did this, Kanna?'

'I don't know,' Raj mumbles incoherently.

Mario snaps his fingers and two guys appear out of nowhere and carry Raj out to the where the car is parked. Khaled holds the door open and asks me to get in. They make Raj lie on the backseat with his head in my lap. My jeans get stained with the blood from his skull.

'Where's the nearest hospital?' I ask Mario.

'Two hours,' he says and grins into the rearview mirror. He turns around to his brother and asks, 'You want some music, Kanna? Music, eh?'

Raj weakly holds a thumb up. Mario laughs like a maniac and proceeds to drive like one. I think I will probably die tonight. Some techno shit plays at an abnormal decibel level. My eardrums will burst and my brain will fall out. We get to the hospital in like twenty minutes and it's a whirl of stretchers and nurses and the rest of it. Mario goes in with his brother and comes out after an hour.

He walks to where we're waiting by the car and calmly lights a cigarette.

'Tomorrow,' he says and looks around. 'Tomorrow, Mapusa will burn.'

Great. Just what I needed. Khaled looks worried. Like he wants to get his ass as far away from this as he can. In a way I'm enjoying this. Mario is a dude.

He drops us back to the hotel and gives me his number.

'You need anything? Call Mario.'

I thank him and give him a big hug. I'll miss him.

≈

Khaled and I don't talk much on the way back. We look out of our respective windows and think to our respective selves. I don't bother with pretending a goodbye.

~

I wait for Rhett and watch the shoemaker hammering away at something. A man and a woman walk by and they're looking at each other like they'd just love to eat each other up. I think I'll call them Nicholas and Victoria. I could call them anything. I could call them Simran and Raj, or Karishma and Karan, or Sarang and something else. But where's the romance in that, really? Sounds better this way. Nicholas and Victoria. Sinister, almost. Mostly because of an old song.

Rhett's bringing his girl along. His girl. Really. Good for him, I say. I don't. I just think it. He says she's gorgeous. Says she's Meyrick's sister. Never knew Meyrick had a sister. A guy, looks like Cobain, passes by in front of me. Blue eyes and cleft chin. Baby's got blue eyes. Bad vibes coming off him. Just looking at him makes my skin crawl. Two nuns on the other side of the road. Laughing, smiling, waiting to cross through the traffic. One of them looks at me. Eye-contact for a second. She looks away quick. Something strange about her.

I see them get out of the car. She looks around and sees me. Rhett waves out. Even from here I can see he's wearing the t-shirt I gave him last Christmas. I wave back. It could be sweet. But hey what do I know? I'm not even too sure where I stand in the food chain. All I can do is think about this and think about that.

Bombay
10 December 2003

Acknowledgements

Thank you:

Judith Nazareth for being a walrus, tsunami and commiserative fellow proofreader & vegetating with me through thick and thin.

S. Jose, M. D'Souza, R. D'Sousa, K.C.D. (Dick by name and dick by nature), S. Suleiman, Weasel, J. De Lincy, Sunny, Manu and S. Sangameswaran variously for being such exceptional allies, schizophrenics, guardian angels, day-trippers & inadvertently providing grist for my fictitious mill.

James LaBrie, John Myung, John Petrucci, Mike Portnoy and Jordan Rudess for Dream Theater.

Dr. Sarvar Sherrychand, Dr. Suguna Ramanathan and Dr. Aniket Jaaware for not numbing my brain under the pretext of education. They made the world of wordmakers and critics a very cool place.

My publisher and designer.

Siddharth D. Patil for being a dude lawyer.

Dennis for praying for my heathen soul & Donald for teaching me how to burp the alphabet—a skill I'm sure will save my life someday.

Peter, my favourite critic, for his valuable suggestions. Keren for all the drunken renditions of *Lucille*.